MW00647070

Heirloom Fruits of America

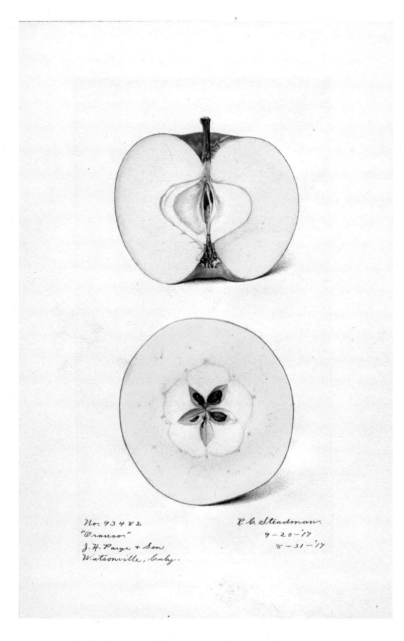

Oranco apple (California, 1917). Artist: Royal Charles Steadman.

Heirloom Fruits of America

Selections from the
USDA Pomological Watercolor Collection

Introduction by Daniel J. Kevles

Heyday, Berkeley, California

Library of Congress Cataloging-in-Publication Data

Names: Kevles, Daniel J., editor.
Title: Heirloom fruits of America : selections from the USDA pomological
 watercolor collection / introduction by Daniel J. Kevles ; watercolor
 and print selections by Daniel J. Kevles and Heyday.
Description: Berkeley, California : Heyday, [2020] | Includes
 bibliographical references.
Identifiers: LCCN 2019058947 | ISBN 9781597145060 (hardcover)
Subjects: LCSH: Fruit--Heirloom varieties. | Botanical illustration.
Classification: LCC SB321 .H44 2020 | DDC 634--dc23
LC record available at https://lccn.loc.gov/2019058947

Cover Art: Tetovka apple (Michigan, 1918). Artist: Royal Charles Steadman.
Cover and Interior Design: Ashley Ingram

Selections by Heyday Staff in consultation with Daniel J. Kevles.
Grateful thanks to Puneeth Kalavase for compilation assistance.

Published by Heyday
P.O. Box 9145, Berkeley, California 94709
(510) 549-3564
heydaybooks.com

Printed in Canada by Friesens Corporation

10 9 8 7 6 5 4 3 2 1

ENVIRONMENTAL BENEFITS STATEMENT

Heyday saved the following resources by printing
the pages of this book on chlorine free paper made
with 100% post-consumer waste.

TREES	WATER	ENERGY	SOLID WASTE	GREENHOUSE GASES
26 FULLY GROWN	2,100 GALLONS	11 MILLION BTUs	90 POUNDS	11,190 POUNDS

Environmental impact estimates were made using the Environmental Paper Network
Paper Calculator 40. For more information visit www.papercalculator.org

Contents

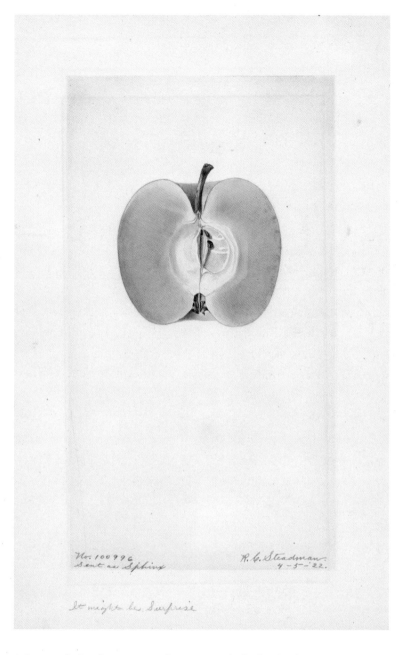

No. 100996
Sent as Sphinx

R. C. Steadman.
4-5-'22.

It might be Surprise

Sphinx apple (Washington, 1922). Artist: Royal Charles Steadman.

Introduction

Daniel J. Kevles

Art has long buttressed political and religious power, and with the advent of modernity, art discovered a variety of new practical purposes, prominent among them the promotion of business interests. The flourishing of American entrepreneurial horticulture in the latter half of the nineteenth century prompted the creation of a federal program of Pomological Watercolors that produced the gorgeous paintings gathered here. Established in the 1880s, the program grew out of several decades of efforts by enthusiasts of American agricultural ingenuity to enlist fruit art in the causes of patriotism, commercial promotion, and the identification of pomological property.

Charles M. Hovey, the proprietor of Hovey & Co., a 40-acre nursery in Cambridge, Massachusetts, led the way when, in 1847, he began publishing a series of handsomely illustrated prints of American fruits. At the time, regional and national agricultural markets were emerging, aided by steamboats, canals, and railroads. The trend was accompanied by expansion in the number of commercial seed and nursery businesses. State horticultural societies dotted the land (Hovey was a stalwart of the Massachusetts Horticultural Society), and in 1848, several of their leaders in the eastern states initiated what became the first national organization of fruit men—the American Pomological Society, its name drawn from Pomona, the Roman goddess of fruits. Marking these developments, in 1853, Hovey gathered his series of prints into a single compendium called *The Fruits of America, Volume 1*, declaring in the preface that he felt "a national pride" in portraying the

"delicious fruits in our own country, many of them surpassed by none of foreign growth," thus demonstrating the developing "skill of our Pomologists" to the "cultivators of the world." Hovey showed further evidence of American pomological skill with the publication of a second volume, in 1856.

Some of those fruits, such as the persimmon, had long been cultivated by Native Americans, but, as Hovey acknowledged, the forebears of most—apple, pear, peach, plum, and cherry trees—were, like most Americans, originally immigrants, brought from England, Europe, Latin America, and, to some extent, Asia. Over time, they became American standards—heirlooms—as they adapted to the nation's environment or generated native varieties via natural cross-pollinations effected by wind, birds, and insects. Among the heirlooms, for example, were two fruits new in the late eighteenth century: the Bartlett pear, which originated in England but came to be grown and renamed by Enoch Bartlett on his farm in Dorchester, Massachusetts; and the Jonathan apple, which was named after Jonathan Hasbrouck, a teenager who found it growing on a farm in Kingston, New York. Both would be memorialized in the Pomological Watercolors—the apple by Royal Charles Steadman and Bertha Heiges, the pear by the latter—and can be seen in this volume (pages 22 and 38). Through the 1850s, a few new indigenous fruit varieties arose from breeding by hybridization, notably Hovey's own widely admired Seedling strawberry, and by sustained selection of natural crosses, which was how Ephraim Bull, a neighbor of Ralph Waldo Emerson, produced the prize-winning Concord grape, eventually also portrayed in all its succulence in a Pomological Watercolor by Deborah Griscom Passmore (page 66).

Hovey's aims with his two volumes of illustrations, however, transcended patriotic celebration. Breeders like him or farmers who found and propagated advantageous new fruits growing in their orchards were eager to protect what we now might call the intellectual property of their pomological varieties. At the time, patent protection

did not extend to living organisms, but the fruit men understood well the economic advantage of preventing others from reproducing and selling their innovations. Operating in increasingly competitive markets, they offered fruit novelties as often as possible. If they were to protect their property, they had to find a way to identify it.

Hovey published the illustrations so that the fruits could be reliably identified in the overlapping circles of horticulture and commerce, especially by the innovators who first brought them out. The nursery catalogues, handbooks, and advertisements of the period reveal that his effort exemplified the beginnings of a small industry of fruit illustration that was an integral part of the pomological trade in the latter half of the nineteenth century. While produced for commercial purposes, much of it was aesthetically arresting. Indeed, combining traditional techniques and new illustrative technology, it generated an abundant and often exquisite body of American botanical art.

The use of pictures was prompted by the proliferation of names that accompanied the multiplication of fruit varieties. Fruits in the United States were bought and sold under a riot of synonyms, creating, Hovey noted, "a confused nomenclature which has greatly retarded the general cultivation of the newer and more valuable varieties." One popular apple, the Ben Davis, was also called Kentucky Streak, Carolina Red Streak, New York Pippin, Red Pippin, Victoria Red, and Carolina Red. William Howsley, a compiler of apple synonyms, called the tendency of "so many old and fine varieties" to be cited in horticultural publications under new names "an intolerable evil, and grievous to be borne."

Variant nomenclature had long plagued botany. Why now such passionate objections to a mere confusion of names? A major reason was that the practice lent itself to misrepresentation and fraud. Whatever their origins—hybrids, chance finds, or imports—improved fruits usually required effort and investment to turn them into marketable products. Unprotected by patents on their productions, fruit innovators could be ripped off in several ways.

In the rapidly expanding nursery industry, a good deal of seedling stock was sold by small nurseries and tree peddlers. They could obtain cheap, undistinguished stock, then tell buyers it was the product of a reliable firm or promote it as a prized variety. Buyers would be none the wiser: a tree's identity did not become manifest until it fruited, and that might not occur until several years after planting.

Fruit innovators also suffered from the kind of appropriation faced by today's originators of digitized music and film. Fruit trees and vines can be reproduced identically through asexual reproduction: the grafting or cloning of scions or cuttings onto sturdy root stock. Competitors could—and did—purchase valuable trees or take cuttings from a nursery in the dead of night, then propagate and sell the trees under a counterfeit rubric. A good apple by any other name would taste as sweet.

Nurserymen like Hovey founded the American Pomological Society in no small part to provide a reliable body of information about the provenance, characteristics, and, especially, names of fruits. The society promptly established a committee on synonyms and a catalogue, hopeful, as its president said, that an authoritative voice would be "the best means of preventing those numerous impositions and frauds which, we regret to say, have been practiced upon our fellow citizens, by adventurous speculators or ignorant and unscrupulous venders."

Yet the society had no police power over names, and its verbal descriptions were often so inexact as to be of little use. For example, it characterized the "Autumn Seek-No-Further" apple as "a fine fruit, above medium size; greenish white, splashed with carmine. Very good."

Drawings, paintings, and colored etchings had long been used to identify botanical specimens, including fruits. During the early nineteenth century in Britain and France, heightened attention was given to the practice of illustration in response to the proliferation of different names for the same fruits. But whether beautiful, as many of the illustrations were, or commonplace, they did not lend themselves to the widespread identification of fruits even in small markets, let alone

the steadily enlarging ones of the United States. Most were hand-painted. Oils and hand-colored etchings or lithographs were laborious and expensive to produce in any number.

Then in the 1830s, Europeans devised color lithography. The technology enabled the production of multiple colored pictures of a subject, including fruits, and it soon crossed the Atlantic to several cities in the northeastern United States. William Sharp, an English painter, drawing teacher, and lithographer, brought it to Boston in 1838 and promptly opened a shop to produce what he called chromo-lithographs.

Charles Hovey enlisted Sharp to provide the colored plates in both volumes of his *Fruits of America*, declaring that his "principal object" in publishing the work was to "reduce the chaos of names to something like order." Together the two volumes included ninety-six vibrant chromolithographs, each handsomely depicting a different fruit with its stem and leaves. However, some critics found chromo-lithographs lacking in fidelity to the delicate tints of nature character-istic of the best plates done by hand.

Chromolithography was a complex, demanding process, an art in and of itself. It required a sophisticated understanding of color, the inventive use of inks, and perfect registration of the print with a dif-ferently colored stone in each of up to a dozen successive impressions. In the coming decades, chromolithographs would greatly improve in quality and would be used in publishing some of the Pomological Watercolors. But at the time, mid-century, aficionados of fruit illus-tration counted as superior to them the portraits produced by the well-established technique of printing black-and-white lithographs that were then watercolored manually.

A much-admired practitioner of the genre was an artist named Joseph Prestele, a German immigrant from Bavaria who had been a staff member at the Royal Botanical Garden in Munich, where he practiced the scientific illustration of botanical specimens. Prestele belonged to the Inspirationists, an ascetic, communitarian offshoot of Lutheranism,

and had been driven by religious harassment to the United States in 1838, settling in the sect's enclave in Ebenezer, New York, and in 1858 moving to Iowa, where a vanguard of Inspirationists had migrated to establish the Amana Colonies. In the 1850s, Prestele pioneered the production of watercolored lithographs for nurserymen, omitting the matter-of-fact features of scientific illustration—seeds, roots, and cross sections of blossoms—in favor of presenting commercially appealing compositions of blossoms and fruits. His standards were high and the work was tedious and slow, but he had three sons, all talented artists, and he managed to produce multiple plates for several nurseries with the sustained help of one and the short-term assistance of another. The third, William, likely participated in the enterprise for a while, but he was a creative spirit and restive in the Inspirationist community. Sometime before 1858, not yet twenty, he left for New York, pursued a career in fruit illustration using his father's methods, and was eventually hired as the first artist in the Pomological Watercolor program.

Joseph Prestele's clients were glad to have his color plates, valuing them as a means to identify and promote their fruit varieties in the market. Copycat entrepreneurs followed his example—some even appropriated his plates—establishing atelier-like facilities where lithographers and watercolorists produced fruit plates in volume. The use of such plates by commercial nurseries rose steadily after the Civil War, amid the ongoing expansion of the fruit industry, and so did the demand for plates produced by chromolithography as that technique grew better and cheaper. Fruit men relished and relied on the colored plates. They not only added pictorial definition to different fruit varieties but also served as a kind of branding in the competitive national market. The images advantaged, collectively, all honest nurserymen and, particularly, the individuals who originated the varieties and named them.

But the advantage was inadequate against the persistent violations of innovators' rights in their fruits. Luther Burbank, the fecund creator of new fruits in Santa Rosa, California, fulminated to the read-

ers of *Green's Fruit Grower* that he had "been robbed and swindled out of my best work by name thieves [and] plant thieves."

To some, part of the trouble was that for all the merits of the pictorial efforts in the horticultural business, none enjoyed national authority. In 1886, in part to offset that deficiency, Congress established the Division of Pomology in the United States Department of Agriculture. To the end of accumulating a reliable national record of fruit varieties, the Division built on the work in fruit illustration of the previous four decades and created the program of Pomological Watercolors from which the images in this book are drawn.

The initiative that led to the Pomological Watercolor Collection was the brainchild of Henry E. Van Deman, who in 1884, while on a train back from a fruit exposition in New Orleans, was thinking about how to enlist the federal government in the pomological cause. The son of an Ohio farmer, Van Deman had fought in the Civil War with the First Ohio Volunteers and later moved to Kansas, where he became a successful orchardist serving the burgeoning homesteader demand for fruit trees. He spent some time in college, but he acquired extensive knowledge of fruits mainly from self-study, including visits to distant orchards, as well as practical experience. Short, sturdy, and pleasant, he became a respected figure on the national horticultural scene, a professor of botany at Kansas State University, and an expert on fruit culture and fruit names who was much in demand as a judge of horticultural expositions and as an untangler of fruit confusions. In the mid-1880s, for example, he worked out the mystery of the Blackman plum, a highly regarded fruit tree that was fecund if bought from one nursery but sterile if bought from another. The explanation was that the stock of the second nursery had been mistakenly derived from the wrong plum tree. Nurserymen who propagated the "mule" tree had lost "thousands of dollars . . . on this worthless freak of nature," Van

Deman noted in the Department of Agriculture report for 1887, but by publicizing it he had halted its distribution and "saved the country from further waste of time and money." The *Rural New-Yorker*, a respected farming magazine, later described him as "a perfect walking encyclopedia of fruit lore."

Van Deman enthusiastically supported the efforts of the American Pomological Society to maintain integrity in fruits. What occurred to him on the train from New Orleans, he recalled at a meeting of the Society in 1897 recorded in its *Proceedings* that year, was that the Society was doing "a public work and . . . that public work should be done at public expense"—in his view, by a federal agency devoted to pomology. While still on his journey home, he proposed the idea to a member of the Department of Agriculture whom he happened to meet in St. Louis. Van Deman's suggestion and perhaps additional efforts by himself and others led to the creation of the Division of Pomology in the department under his directorship. Its central purpose was to promote the nation's pomology industry, not primarily if at all through scientific research but by adding public weight and capacity to the work of the American Pomological Society. It was to be in significant part an information agency.[1]

By the time Van Deman left the directorship in 1893, the Division was on its way to becoming an authoritative clearing house for pomological names, a source of consultative assistance to nurserymen and farmers, and an adviser on the merits of different fruits, including their suitability for different regions of the country. A number of fruit growers sent cuttings of fruits, asking that they be identified. If a variety seemed new and valuable, Van Deman had it planted and tested for robustness of growth and quality of fruit no matter whether it was foreign or domestic in origin.

1. In 1901, the Department of Agriculture moved the Division of Pomology into its new Bureau of Plant Industry. Although it was no longer called a Division, for simplicity's sake I use the original name throughout.

Van Deman and his successors considered fruit identification one of the Division's major tasks. The Division published separate bulletins on the nomenclature of individual fruits. Bulletin Number 56, on the nomenclature of the apple, was especially popular, judging by the number of requests made for it. The Division informed growers if the name for a fruit they were selling was merely a synonym for an established type known under its primary name. In 1896, Samuel B. Heiges, Van Deman's successor as director, reported that the growers usually adopted the correct name, even at the cost of profits to themselves. In the department's report for that year, he held that providing such information was one of the Division's "most useful functions . . . for the correct nomenclature of fruit varieties in nurseries and orchards is one of the most important factors in progressive commercial fruit growing."

From the beginning, Van Deman enlisted art in the interest of identification, hiring artists to produce drawings, watercolors, and painted wax models of fruits submitted to the Division that proved to be of interest. He recruited William H. Prestele as the Division's initial artist in 1887, paying him $1,000 a year, a sum that, comprising about a third of the Division's budget, bespoke the importance Van Deman attached to having him. Forty-nine years old, Prestele had by then extensive experience in producing watercolored lithographs of fruits for nurserymen, both working for them and as the proprietor of his own business. In 1869, his efforts won high praise from *Gardener's Monthly and Horticultural Advertiser*: "We are in the habit of admiring European art in this line, and have often wished Americans could successfully compete with it. [In Prestele,] *We now have it here.* We never saw anything of the kind better executed from any part of the world."

The Division was primarily engaged in establishing a record of the submitted fruits rather than in producing multiple plates for widespread distribution. Prestele thus did not need to use multiple black-and-white lithographs that he would then color himself or supervise others in coloring. He had only to paint a single watercolor of each

fruit. However, the Division selected some of the paintings for publication in the annual *Reports* or *Yearbooks* of the Department of Agriculture to promote attention to the fruit by nurserymen and farmers. Since those volumes were distributed by the thousands, the selected watercolors were made the basis of mass-reproducible chromolithographs.

In his work for the Division, Prestele painted the whole fruit either standing alone or on the branch nestled in its adjacent twigs and leaves. Employing one traditional characteristic of botanical illustration that was intended to assist in distinguishing varieties, he usually included in both forms of composition a cross section of the interior showing the seeds. In both, he gave the fruit a lifelike texture with rich coloring and exquisite detail, rendering it with a naturalness and grace that made it appealing for plucking and eating. His style is exemplified in his elegant rendering, in the *Report of the Commissioner of Agriculture* for 1888, of the pear named the Wilder (page 43), after Marshall Wilder, who was famous among pomologists for his pear orchard and was a founder and longtime president of the American Pomological Society.

The paintings were, Van Deman declared in one of his annual reports, "invaluable for comparison and reference." He proudly noted that "together with carefully written descriptions," they constituted a kind of permanent "cabinet of records," "not only of scientific interest to pomology, but also of practical value to the industry it represents."

Prestele produced most of his watercolors during Van Deman's tenure—all told, more than 140 of them between 1887 and 1894, the year before his death. Together they established a compelling standard of fruit portraiture for the artists who followed him to emulate.

Van Deman began hiring additional artists in 1892, and his successors followed suit, employing a total of twenty artists through 1942, when

the watercolor program ended. Overall, counting Prestele's work, the Division staff produced some 7,100 paintings, but about 5,400— roughly three-quarters of them—were painted in the first half of the program's life, between 1887 and 1916. Still, although the need for watercolor portraits of the nation's fruits then declined as other forms of color illustrations took hold, the Division's artists subsequently added 1,700 more watercolors to the pomological collection.

Apart from Prestele's paintings, almost all of the 7,100 watercolors were the work of only eight of the twenty artists, six of them women: Mary Daisy Arnold, Bertha Heiges, Elsie E. Lower, Amanda Almira Newton, Deborah Griscom Passmore, and Ellen Isham Schutt, all hired between 1892 and 1908. This super-productive group was completed by James Marion Shull and Royal Charles Steadman, who joined in, respectively, 1909 and 1915. Together they comprised a remarkably capable coterie of pomological watercolorists.

The first of the eight to join the staff was Passmore, a worthy successor to Prestele. The product of a Quaker family in Pennsylvania, she had trained at the School of Design for Women and the Academy of Fine Arts in Philadelphia, studied for a year in Europe, and, on her return to the United States, begun teaching art and painting the wildflowers of America. Her work impressed William W. Corcoran, the founder of the Corcoran Gallery of Art in Washington, D.C. At his initiative, she moved to the city, apparently expecting to work under his wing, but when Corcoran died in 1888, soon after her arrival, she found other work and then joined the Division of Pomology. Van Deman, recognizing her remarkable qualities, designated her the leader of the artistic staff.

Little biographical information on Arnold is available, and Heiges, who was Samuel B. Heiges's daughter-in-law, left no known personal record, but what we know of the others suggests the anatomy and dynamics of the group. At least three, in addition to Passmore, were formally trained in art—Arnold somewhere in New York City, Lower at the Corcoran School of Art in Washington, which was associated

with the Corcoran Gallery, and Steadman at the School of the Museum of Fine Arts and the Cowles Art School, both in Boston. Newton came to her position as a kind of birthright, being a granddaughter of the first Commissioner of Agriculture, Isaac Newton. Concrete information about the careers of the Division's artists provided by the USDA indicates that they worked in an environment of collegial camaraderie and programmatic stability.

The Division's mainstays were Passmore, who held her job for twenty years until her death in 1911; then Newton and Arnold, who each remained in the Division for thirty-three years and between them covered the period from 1896 to 1940; and Steadman, who was on the staff for twenty-nine years, from 1915 to the program's conclusion. A friendship apparently grew between Steadman and Newton, coworkers for thirteen years; it likely arose from their common interest in making wax models of fruits that were submitted to the Division. In 1896, Newton began fabricating such models—they were sufficiently innovative and attractive to warrant showing at the USDA exhibit at the St. Louis World's Fair in 1904—and Steadman devised and patented a method for strengthening their hollow interiors so that they would not collapse under stress. Steadman painted a portrait of Newton's grandfather, Isaac, when she requested the favor.

Passmore was astonishingly prolific, producing some 1,500 pomological drawings and watercolors, greater than the total for anyone else and at an average rate—76 per year—that exceeded everyone else's as well. Newton and Arnold together contributed just short of 2,300 watercolors to the pomological collection, and Steadman added almost 900 more. All told, these four artists painted 4,700 fruit watercolors, almost two-thirds of the collection total. The next tier down was occupied by Shull, with almost 780 paintings, and by Heiges and Schutt, who worked, respectively, for thirteen and eleven years in the Division and produced between them more than 1,300 watercolors.

Elsie Lower was there only five years, from 1908 to 1912, when she left for California with her husband, a pomologist who helped

develop the state's navel orange industry. The brevity of her stay, how-ever, was offset by the evident expansiveness and quality of her talent. Before her departure, she produced almost 290 paintings, includ-ing a luscious rendering, reproduced here, of the Diploma currant (page 52). In California, she achieved distinction as a painter of the citrus enterprise and then, working in oils as well as watercolors, of award-winning California scenes.

Along with Prestele, Passmore stands out for the quality of her work in the first half of the Division's history, and Steadman takes the garland in the second half. Passmore prided herself on rendering her subjects with minute accuracy and took great pains to achieve vital tones suitable to the fruit, characteristics exemplified in her water-color of the Concord grape and of the Headlight grape, which is also available here (page 67). Steadman, before joining the Division, had supplemented his art training with study at the Rhode Island School of Design and had achieved success in a commercial firm as a jewelry designer. His watercolors, diverse examples of which are represented in this collection, tended to delicacy and meticulous detail, jewellike renderings across a stunning range of familiar fruits such as strawber-ries, grapes, citrus (lemons, limes, grapefruits, and oranges), plums, pears, persimmons, and watermelons, and of then largely unfamiliar ones, at least to Americans in the East and Midwest, such as mangoes and avocados. His watercolor of the Queen avocado, from the Gua-temala Avocado Nursery in Yorba Linda, California, captured all the roughness of its skin while inviting contemplation of its hidden edible meat (page 58).

Amanda Newton's paintings exude vitality even when showing, as most did, a whole fruit and its cross section floating in space, but she also painted strawberries, cherries, and gooseberries, an example of which appears here (page 54), that, often with cross sections, ten-derly depicted the fruits amid their foliage. Shull's watercolors, many of them of apples and citrus, were capably executed; suffused partly by a scientific and instructive intent—the artist was the older brother of

George Harrison Shull, one of the country's leading plant geneticists, and was himself devoted to botanic science—they largely depicted the fruits by themselves and in some cases twigs cut into for grafting. Heiges devoted herself in the main to peaches, pears, apples, and plums, painting most of them, as she did the Bartlett, as standalones and cross sections and giving them life by subtle use of light and modulation of color in rendering the fruit's skin and shape. Schutt's work was competent, adequate for the many nuts she painted but in her fruits often tending toward flat lifelessness, as in the painting here of the Winter Paradise apple (page 21).

Each of the principal artists painted numerous apples, making that fruit by far the largest in number—3,340—among all the pomological watercolors; the apples were followed by peaches and nectarines, the subjects together of 930 of the watercolors, putting them at a distant second but still slightly more than twice as numerous as the next in line, pears, with 390, and then plums, at 350. The next-best-represented fruits comprised grapes, strawberries, and sweet and sour oranges, which in sum appear in 790 of the watercolors. Taken together, this basket of standard American fruits totaled 5,800 specimens, or about three-quarters of the paintings. More than a dozen fruits made up the rest: most of them—cherries, grapefruits, lemons, blackberries, and raspberries—increasingly common on American tables, the rest mid-nineteenth-century imports such as mangoes, kumquats, and guavas—a luscious illustration of which done by Prestele can be seen here (page 79)—for which Americans were only then acquiring a taste.

The dominance of apples, peaches, and nectarines reflected not only the appeal of these fruits to the palate but also their importance since colonial days in the farm economy and now to the rapidly expanding urban population. Apple orchards were mainly devoted to the production of cider and applejack. Cider was long a staple drink at the family dining table and a coin of barter in rural America. The produce of peach orchards was largely turned into peach brandy, with

the fallen surplus used to fatten hogs. In both rural and urban America, fruits substituted for sugar, which was scarce in the nineteenth century and still expensive in the early twentieth. Apples were especially valued because, unlike virtually every other fruit, many varieties would remain fresh, juicy, and tasty for many months. And in the early twentieth century, the industry began promoting them as a benefit to health with the slogan "An apple a day keeps the doctor away."

At the time of the Division's creation, the United States remained an importer of new fruits, as it still is today. Many of the new arrivals continued to come from Europe and Latin America, but they were now enriched with more fruits from the Far East. The federal government had long encouraged diplomatic and military officers to keep an eye out in their foreign posts for promising plants. In 1898, enlarging on that strategy, the Department of Agriculture established the Office of Seed and Plant Introduction, which sent plant explorers across the world. The effort yielded a number of fruits, such as the Meyer lemon (see page 103), brought from China by Frank Meyer, an intrepid traveler who died of drowning in the Yangtse River in 1915, having fallen, jumped, or been pushed into it from the junk on which he was traveling. Americans initially valued these imports as exotics, but, becoming commonplace, they eventually earned standing as heirlooms beside those of longer histories in the nation.

Chance finds in the fields by nurserymen, farmers, and orchardists also remained a major source of new fruits. In the early 1890s, a farmer in Peru, Iowa, named Jesse Hiatt happened upon an appealing random cropping—a tasty red-and-vermillion-striped apple unique in its appearance for having five distinctive bumps in a circle at its bottom. He sent it to Stark Brothers Nursery in Louisiana, Missouri, as a competitor in its annual fruit fair. Stark bought the rights in the tree from Hiatt, named it the Delicious apple, and marketed it in the company's catalogues. In the 1920s, renamed the "Red Delicious" to distinguish it from Stark's new "Golden Delicious," it became one of the most popular apples in the United States. Passmore painted a

watercolor of it (page 23), which appeared as a chromolithograph in the Department of Agriculture's *Yearbook* for 1907.

Then, too, beginning in the late nineteenth century, the advent of cooled and then refrigerated freight cars stimulated chance finders and fruit breeders in the West and South to meet the hunger for new fruits in the Midwest and East. The incentives advantaged breeders on the West Coast such as Luther Burbank, a friend of Van Deman, after whom Burbank named a quince. Among his early triumphs was the Burbank plum, which would become one of the best-known plums in the United States and which is shown here (page 47), an image painted by Prestele that was published in the *Report of the Secretary of Agriculture* for 1891.

However, with international markets growing more competitive, the US government was taking steps to strengthen the development of new agricultural products by supplementing private enterprise with public arrangements. In 1887, it authorized the creation of agricultural experiment stations at every land-grant university in the United States, funding them for a variety of purposes, including the breeding of new fruits. Several of the fruits illustrated here—for example, the Admiral Dewey peach and the Lafayette plum, as well as the Winter Paradise apple—originated on one experiment station or another.

Most of the originals of the Pomological Watercolor Collection are housed in the USDA Agricultural Library in Beltsville, Maryland. However, perhaps as many as 200 were lost in the process of publishing them as the chromolithographs that appeared in annual volumes from the Department of Agriculture from the beginning of the program to 1916, when the publication of the selections ended. Among the strengths of the Pomological Watercolors in this volume is that the collection includes thirty-seven of the lost illustrations, all of them striking, thus making them widely accessible for the first time in more

than a century. The rest of the selections presented here are reproduced directly from the originals in the library at Beltsville.

The watercolors gathered in these pages offer a selection of the most striking images from this bountiful time in American horticulture, before the rise of industrial agriculture, emphasizing efficiency and uniformity, left us with only a handful of fruit varieties. Here you will find both common and unfamiliar fruits grown across the broad span of these United States. This book is also, of course, a celebration of the remarkable artists who painted them. The result is a gem—a collection of watercolors that is both strikingly pleasing to the eye and expressive of the diversity in origin and content of the nation's basket of heirloom fruits.

Selected Sources

Kevles, Daniel J. "Cultivating Art." *Smithsonian Magazine* 42 (July/August 2011), 76–82.

Last, Jay T. *The Color Explosion: Nineteenth-Century American Lithography* (Santa Ana, CA: Hillcrest Press, 2005).

Pauly, Philip J. *Fruits and Plains: The Horticultural Transformation of America* (Cambridge: Harvard University Press, 2008).

Ravenswaay, Charles van. *Drawn from Nature: The Botanical Art of Joseph Prestele and His Sons* (Washington, D.C: Smithsonian Institution Press, 1984).

US Department of Agriculture. *Report of the Commissioner of Agriculture*, 1885–1888.

———. *Report of the Secretary of Agriculture,* 1889–1893.

———. *USDA Pomological Watercolors, NAL Digital Collections.* usdawatercolors.nal.usda.gov/pom/home

———. *Yearbook*, 1897–1916.

White, James, J., and Erik L. Neumann. "The Collection of Pomological Watercolors at the U.S. National Arboretum." *Huntia* 4(2), 103–23.

Acknowledgments

This essay draws on work supported by the Books Program of the Alfred P. Sloan Foundation, the National Science Foundation, the Cullman Center for Scholars and Writers at the New York Public Library, and the Humanities Institute at the LuEsther T. Mertz Library, New York Botanical Garden. My thanks to them all, and to Marthine Satris for her insightful editorial suggestions and Christopher Wood for a comment on the history of art.

DANIEL J. KEVLES is the Stanley Woodward professor emeritus of history, history of medicine, and American studies at Yale University. He is the author/editor of seven books, notably *In the Name of Eugenics: Genetics and the Uses of Human Heredity*. He is currently completing *Vital Properties: A History of Innovation and Ownership in the Stuff of Life*, to be published by Alfred A. Knopf. Kevles has also written dozens of articles and essays for publications, including *The New York Review of Books*, *The New Yorker*, *Scientific American*, *Smithsonian Magazine*, and the *Times Literary Supplement*.

Plates

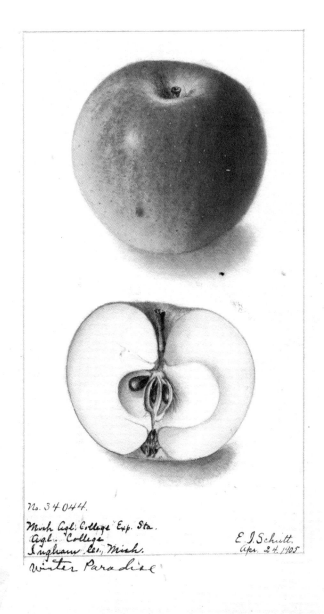

No. 34044.

Mich. Agl. College Exp. Sta.
Agl. College
Ingham Co., Mich.

E. I. Schutt,
Apr. 24. 1905

Winter Paradise

Winter Paradise apple (Michigan, 1905). Artist: Ellen Isham Schutt.

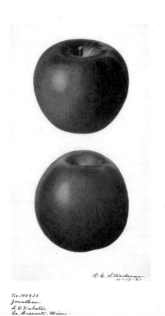

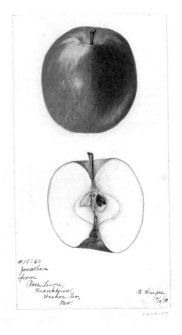

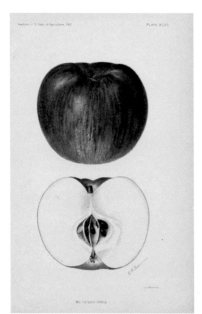

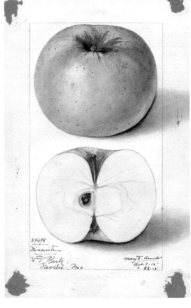

Clockwise from top left: Jonathan apple (Minnesota, 1921). Artist: Royal Charles Steadman. Jonathan apple (Nevada, 1898). Artist: Bertha Heiges. Nixonite apple (Missouri, 1915). Artist: Mary Daisy Arnold. McIntosh apple (New York, 1901). Artist: Deborah Griscom Passmore.

Yearbook U. S. Dept. of Agriculture, 1907. PLATE XXIX.

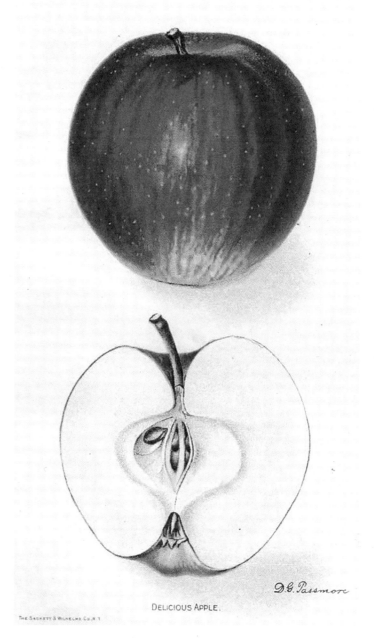

DELICIOUS APPLE.

THE SACKETT & WILHELMS CO., N.Y.

Delicious apple (Iowa, 1907). Artist: Deborah Griscom Passmore.

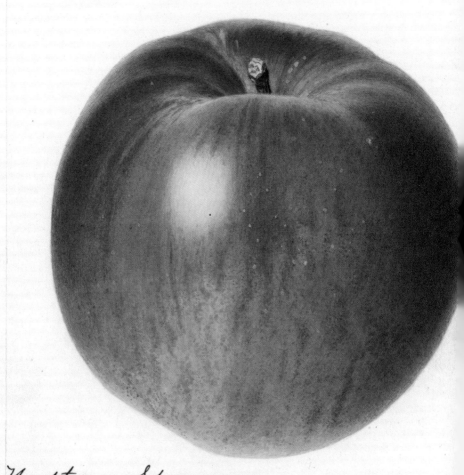

Northern Spy.
No. 96354
Wm. Andrews
So. Haven, Mich.

R. C. Steadman.
11 – 6 – '18
10 – 23 – '18

Northern Spy apple (Michigan, 1918). Artist: Royal Charles Steadman.

 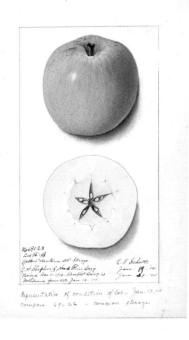

Left: Summer Pound apple (Virginia, 1921). Artist: Amanda Almira Newton.
Right: Yellow Newton apple (Oregon, 1914). Artist: Ellen Isham Schutt.

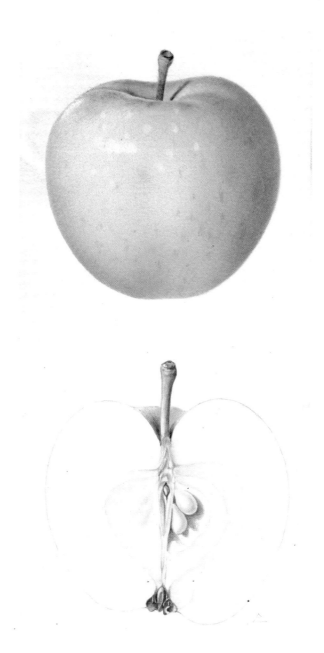

Lodi apple (Maryland, 1937). Artist: James Marion Shull.

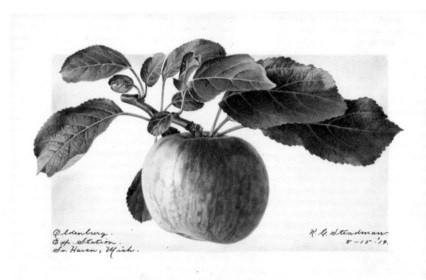

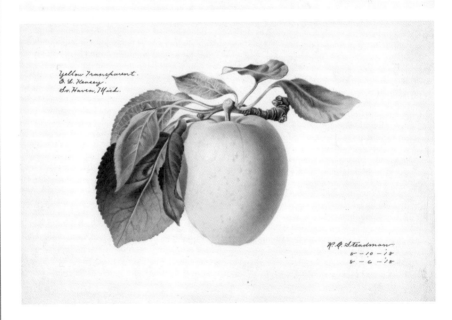

Top: Oldenburg apple (Michigan, 1919). Artist: Royal Charles Steadman.
Bottom: Yellow Transparent apple (Michigan, 1918). Artist: Royal Charles Steadman.

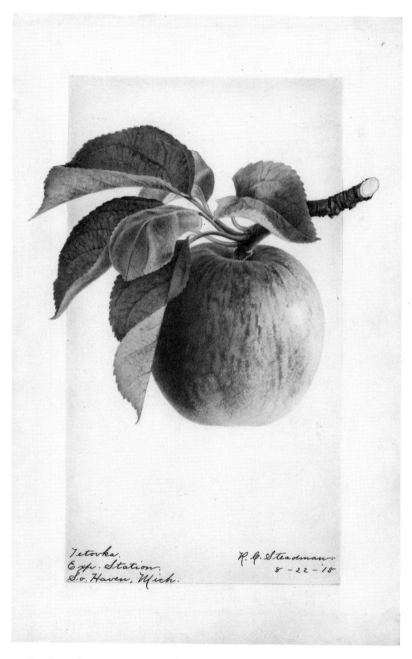

Tetovka apple (Michigan, 1918). Artist: Royal Charles Steadman.

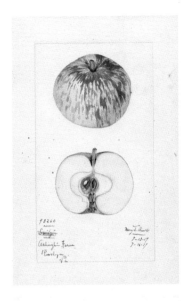

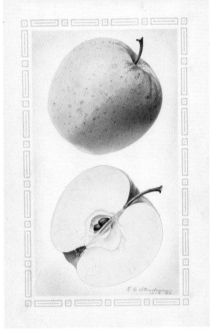

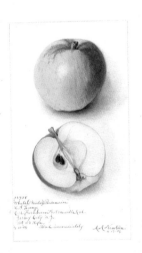

Clockwise from top left: Switzer apple (Virginia, 1917). Artist: Mary Daisy Arnold. Golden Delicious apple (Virginia, 1922). Artist: Royal Charles Steadman. White Winter Pearmain apple (California, 1906). Artist: Amanda Almira Newton.

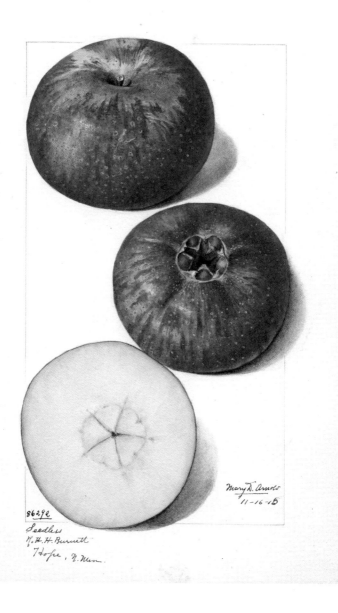

Apple (New Mexico, 1915). Artist: Mary Daisy Arnold.

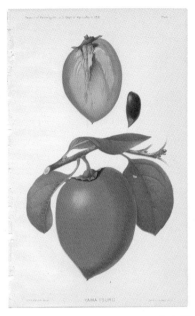

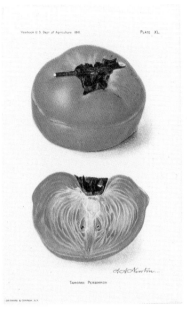

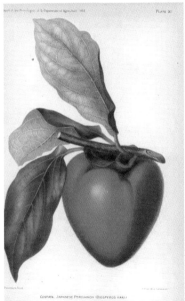

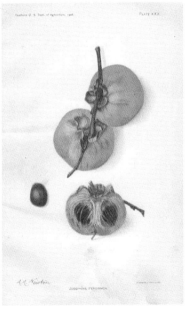

Clockwise from top left: Yama Tsuru persimmon (Florida, 1891). Artist: William Henry Prestele. Tamopan persimmon (Florida, 1910). Artist: Amanda Almira Newton. Josephine persimmon (Texas, 1906). Artist: Amanda Almira Newton. Costata persimmon (Florida, 1892). Artist: Deborah Griscom Passmore.

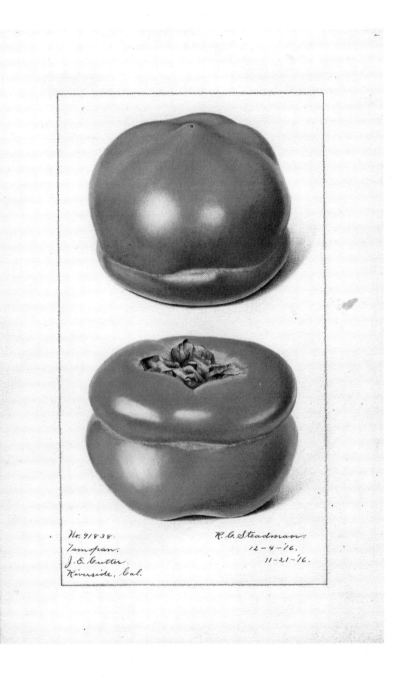

Tamopan persimmon (California, 1916) Artist: Royal Charles Steadman.

Plate X

Report of Pomologist U.S. Dept. of Agriculture 1889.

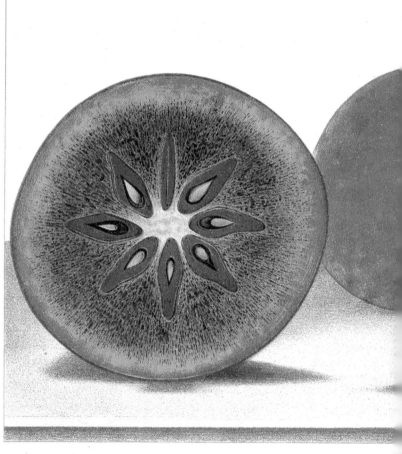

Wᵐ H. Prestele. Fecit.

Y

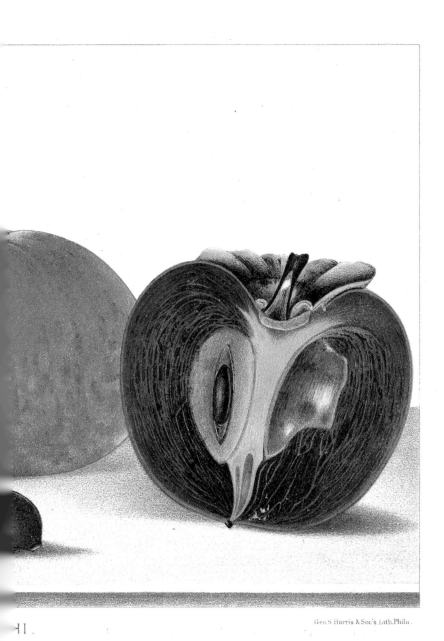

Geo.S.Harris & Son's Lith.Phila.

Yeddo Ichı persimmon (Florida, 1889). Artist: William Henry Prestele.

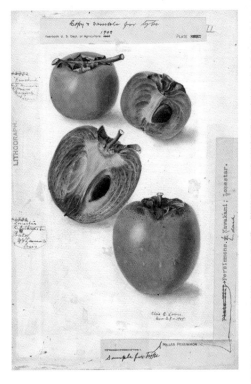

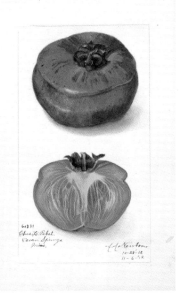

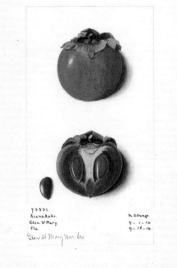

Clockwise from left: Kawakami and Lonestar persimmons (Texas, 1908). Artist: Elsie E. Lower. Persimmon (Mississippi, 1912). Artist: Amanda Almira Newton. Kianakaki persimmon (Florida, 1914). Artist: M. Strange.

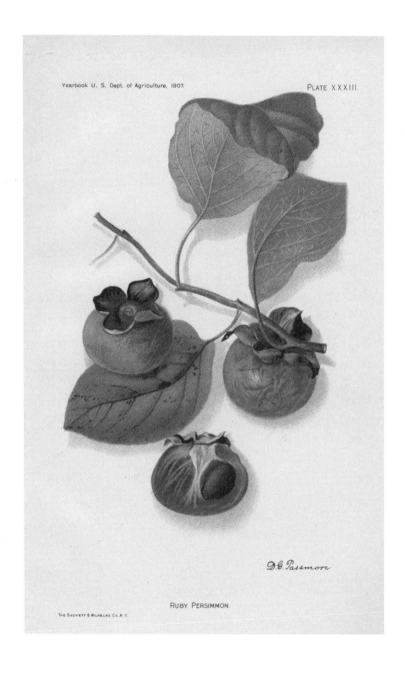

Yearbook U. S. Dept. of Agriculture, 1907.

PLATE XXXIII.

THE SACKETT & WILHELMS CO.,N.Y.

RUBY PERSIMMON.

Ruby persimmon (Indiana, 1907). Artist: Deborah Griscom Passmore.

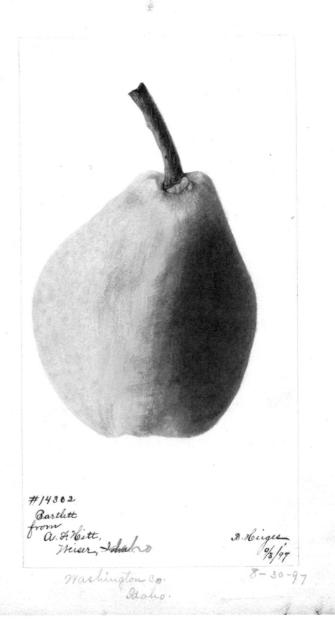

#14302
Bartlett
from
A. F. Hitt,
Weiser, Idaho

B. Heiges
9/3/97

8-30-97

Washington Co.
Idaho.

Bartlett pear (Idaho, 1897). Artist: Bertha Heiges.

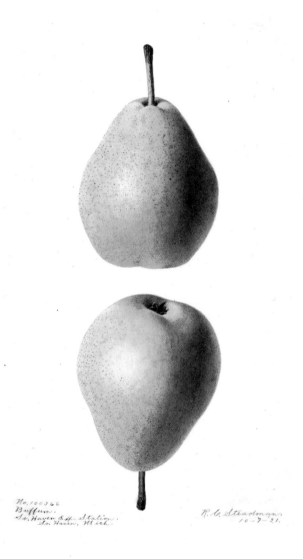

Buffum pear (Michigan, 1921). Artist: Royal Charles Steadman.

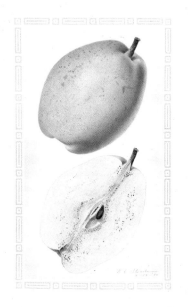

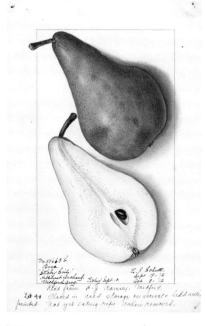

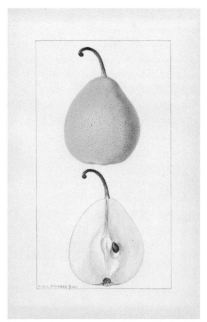

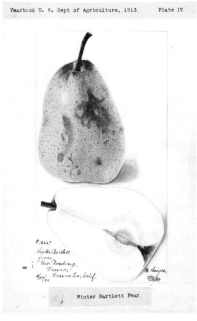

Clockwise from top left: Baldwin pear (Alabama, 1930). Artist: Royal Charles Steadman. Bosc pear (Oregon, 1912). Artist: Ellen Isham Schutt. Winter Bartlett pear (California, 1899). Artist: Bertha Heiges. Michigan U.S. 431 pear (Maryland, 1936). Artist: Louis Charles Christopher Krieger.

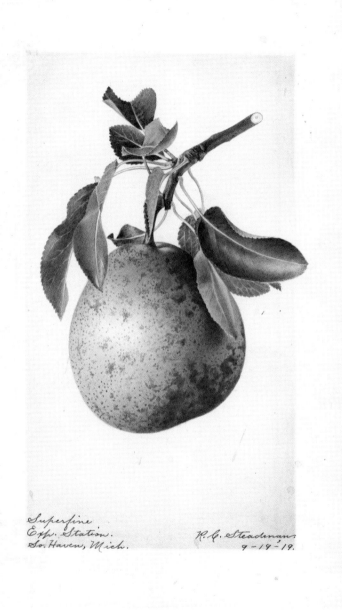

Superfine
Exp. Station.
So. Haven, Mich.

R. C. Steadman
9 - 19 - 19.

Superfine pear (Michigan, 1919). Artist: Royal Charles Steadman.

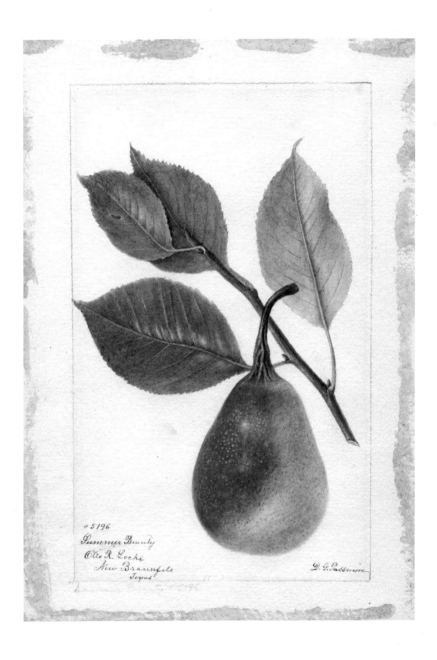

#5196
Summer Beauty
Otto R. Locke
New Braunfels
Texas

D. G. Passmore

Summer Beauty pear (Texas, 1893). Artist: Deborah Griscom Passmore.

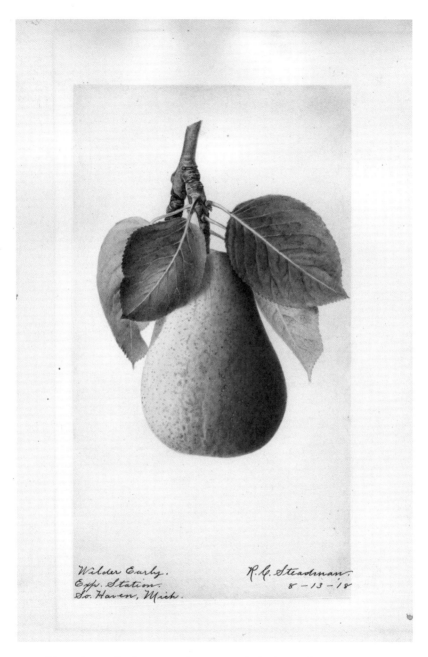

Wilder Early pear (Michigan, 1918). Artist: Royal Charles Steadman.

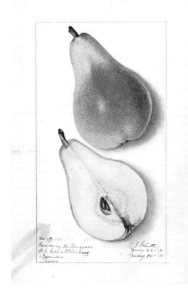
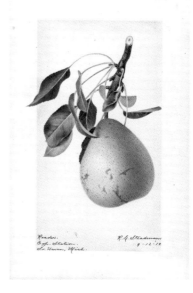
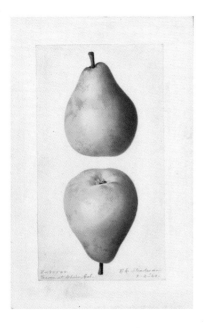
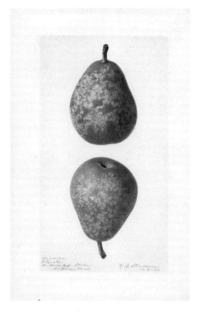

Clockwise from top left: Souvenir du Congress pear (Texas, 1912). Artist: Ellen Isham Schutt. Reader pear (Michigan, 1919). Artist: Royal Charles Steadman. Fitzwater pear (Michigan, 1921). Artist: Royal Charles Steadman. Pear (California, 1920). Artist: Royal Charles Steadman.

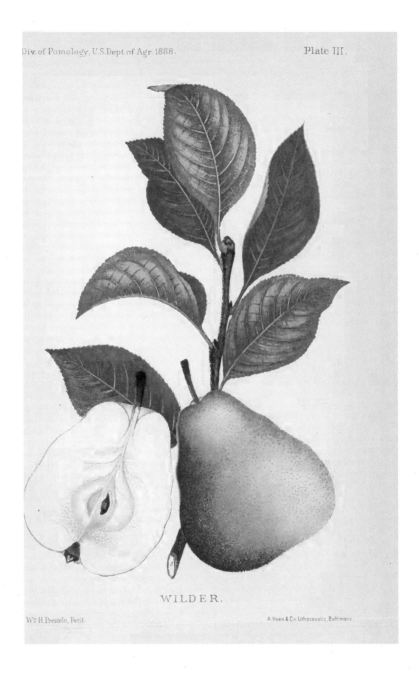

Plate III.

WILDER.

Wᵐ H. Prestele, Fecit.

A. Hoen & Co. Lithocaustic, Baltimore.

Wilder pear (New York, 1888). Artist: William Henry Prestele.

Farmosa plum (Maryland, 1940). Artist: Mary Daisy Arnold.

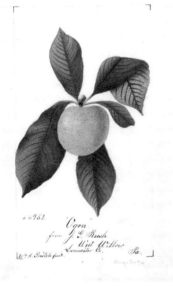

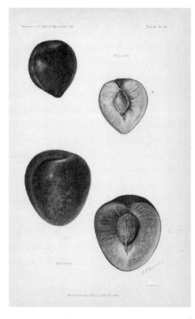

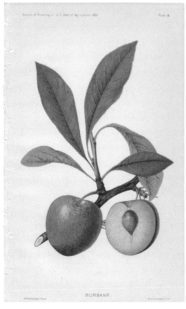

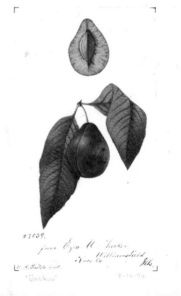

Clockwise from top left: Ogon plum (Pennsylvania, 1894). Artist: William Henry Prestele. Wickson and Red June plums (Virginia, 1901). Artist: Deborah Griscom Passmore. Tucker plum (Illinois, 1894). Artist: William Henry Prestele. Burbank plum (New York, 1891). Artist: William Henry Prestele.

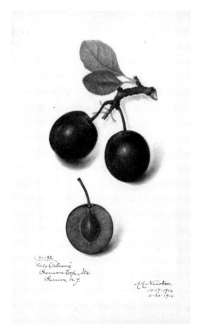
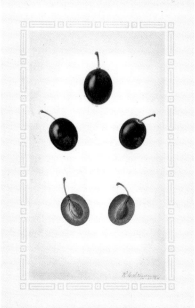
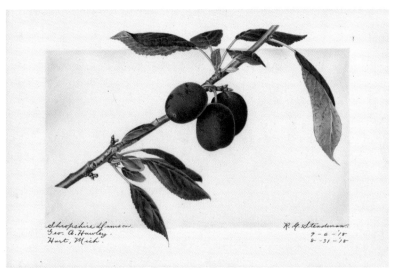

Clockwise from top left: Late Orleans plum (New York, 1916). Artist: Amanda Almira Newton. Mackinan plum (Michigan, 1924). Artist: Royal Charles Steadman. Shropshire Damson plum (Michigan, 1918). Artist: Royal Charles Steadman.

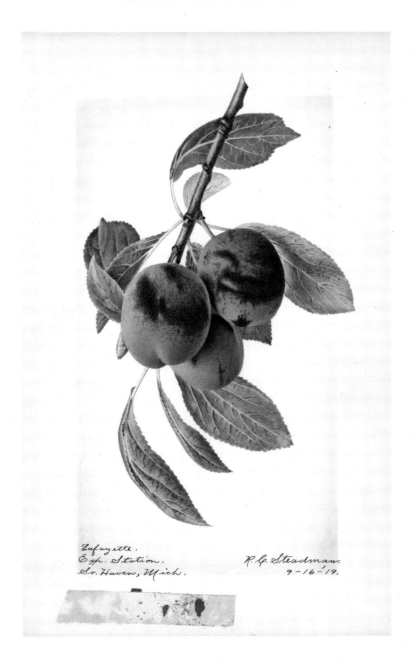

Lafayette plum (Michigan, 1919). Artist: Royal Charles Steadman.

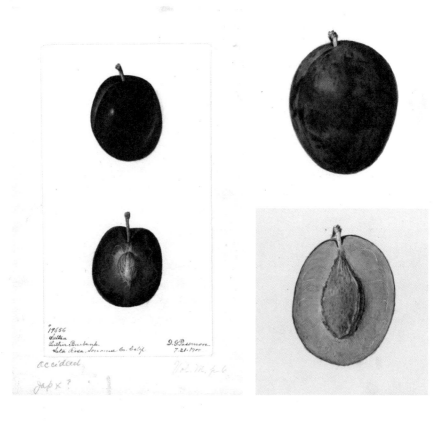

Left: Sultan plum (California, 1900). Artist: Deborah Griscom Passmore.
Right: President plum (California, 1935). Artist: Louis Charles Christopher Krieger.

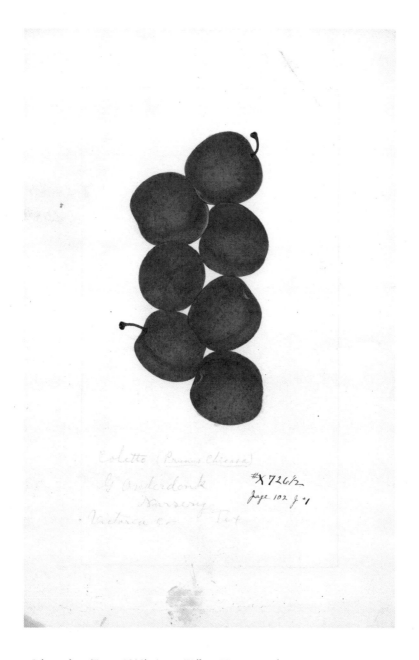

Coletto plum (Texas, 1888). Artist: William Henry Prestele.

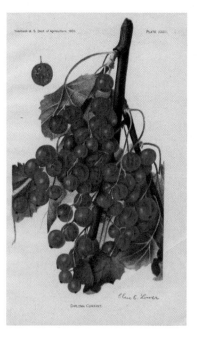 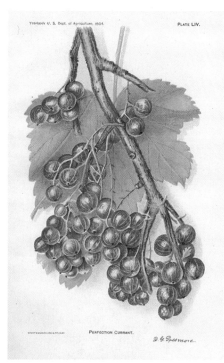

Left: Diploma currant (New York, 1909). Artist: Elsie E. Lower.
Right: Perfection currant (New York, 1904). Artist: Deborah Griscom Passmore.

port of Pomologist U.S.Dept.of Agriculture 1889.

Plate III.

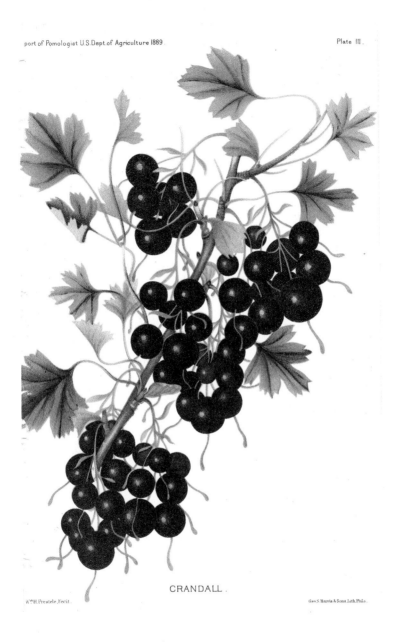

CRANDALL.

W^mH.Prestele,Fecit.

Geo.S.Harris & Sons.Lith.Phila.

Crandall currant (Kansas, 1889). Artist: William Henry Prestele.

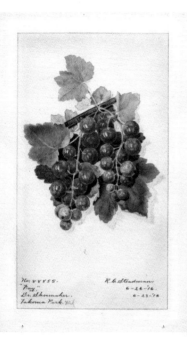

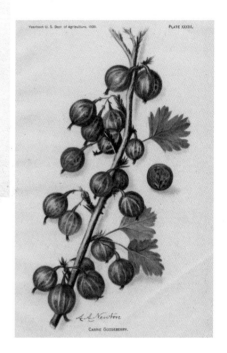

Left: Fay gooseberry (Maryland, 1916). Artist: Royal Charles Steadman.
Right: Carrie gooseberry (Minnesota, 1909). Artist: Amanda Almira Newton.

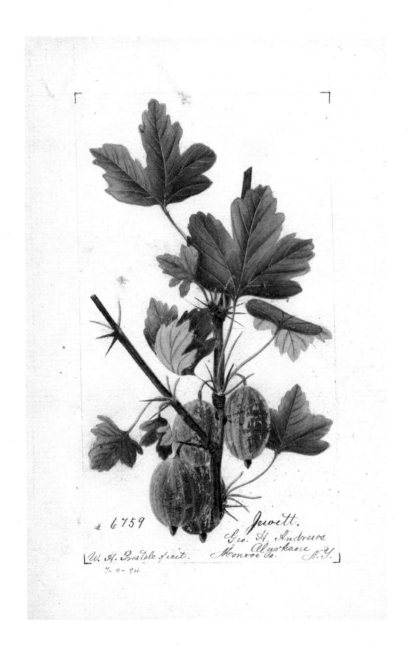

Jewett gooseberry (New York, 1894). Artist: William Henry Prestele.

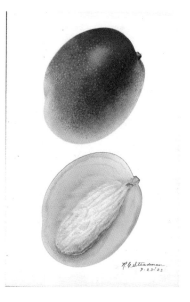
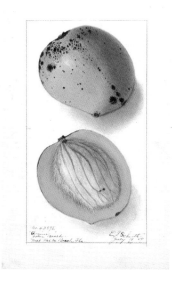
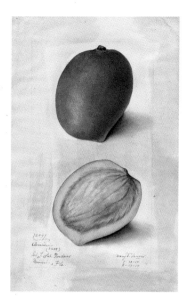
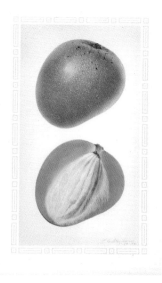

Clockwise from top left: Hayden mango (Florida, 1923). Artist: Royal Charles Steadman. Amiri mango (Florida, 1909). Artist: Ellen Isham Schutt. Baboony mango (Florida, 1926). Artist: Royal Charles Steadman. Amiri mango (Florida, 1914). Artist: Mary Daisy Arnold.

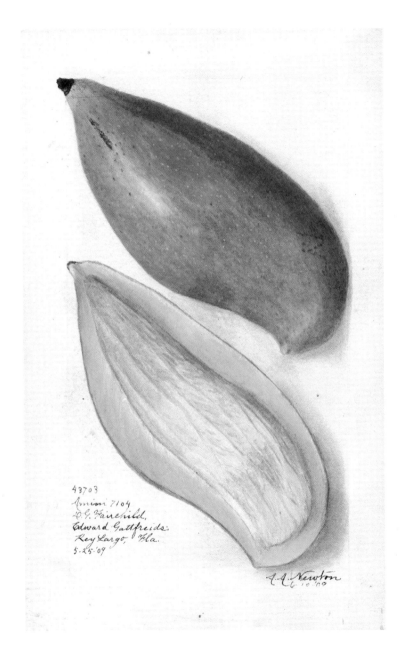

43703
Amiri 7104
D.G. Fairchild,
Edward Gattfreids:
Key Largo, Fla.
5.25.'09

A.A. Newton
6.10.'09

Amiri mango (Florida, 1909). Artist: Amanda Almira Newton.

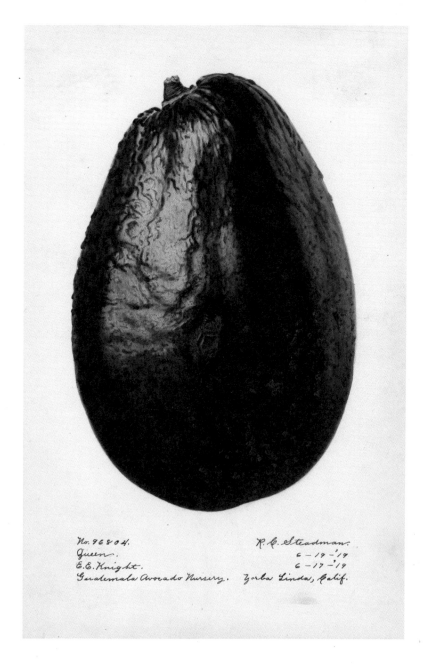

Queen avocado (California, 1919). Artist: Royal Charles Steadman.

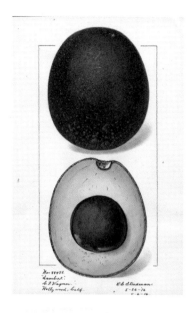
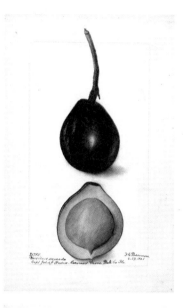
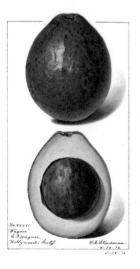
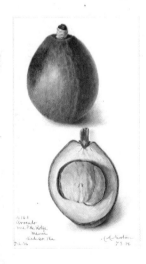

Clockwise from top left: Sambert avocado (California, 1916). Artist: Royal Charles Steadman. Mexican avocado (Florida, 1901). Artist: Deborah Griscom Passmore. Avocado (Florida, 1906). Artist: Amanda Almira Newton. Wagner avocado (California, 1916). Artist: Royal Charles Steadman.

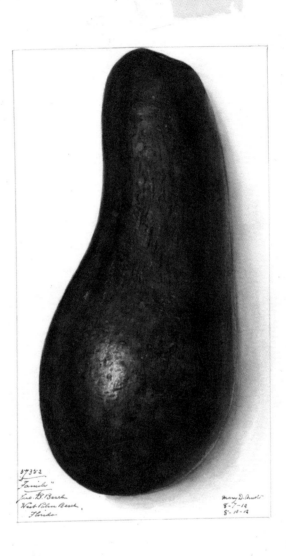

57352
"Family"
Jno. B. Beach
West Palm Beach,
Florida

Mary D. Arnold
8-7-12
8-10-12

Family avocado exterior (Florida, 1912). Artist: Mary Daisy Arnold.

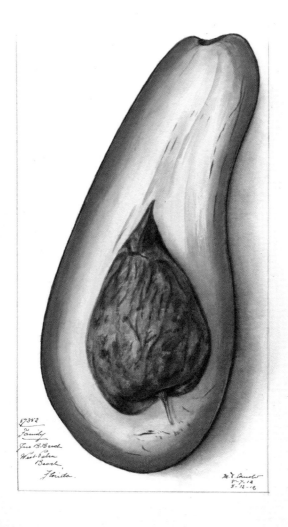

Family avocado interior (Florida, 1912). Artist: Mary Daisy Arnold.

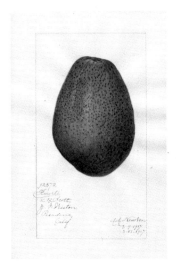
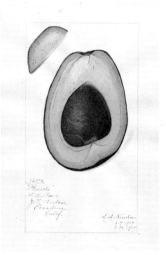
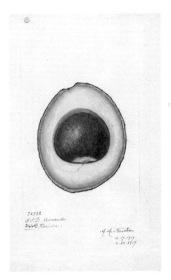
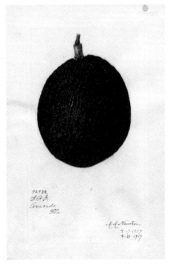

Clockwise from top left: Fuerte avocado exterior (California, 1917). Artist: Amanda Almira Newton. Fuerte avocado interior (California, 1917). Artist: Amanda Almira Newton. McDonald avocado exterior (Florida, 1917). Artist: Amanda Almira Newton. McDonald avocado interior (Florida, 1917). Artist: Amanda Almira Newton.

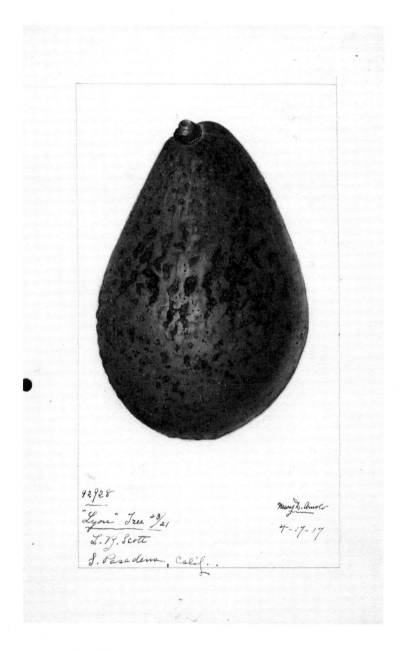

92928
"Lyon" Tree #3/21
L. W. Scott
S. Pasadena, Calif.

Mary D. Arnold
4-17-17

Lyon avocado (California, 1917). Artist: Mary Daisy Arnold.

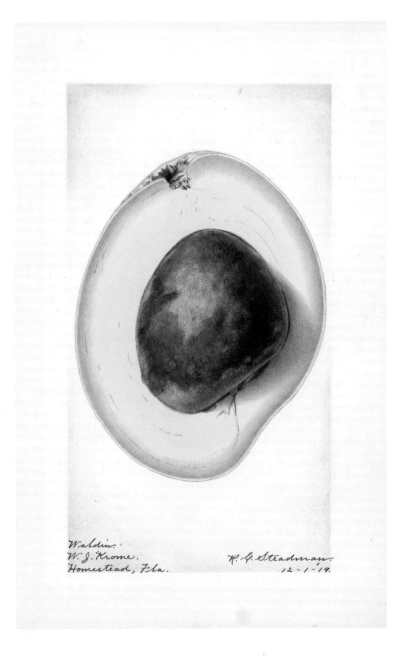

Waldin avocado interior (Florida, 1919). Artist: Royal Charles Steadman.

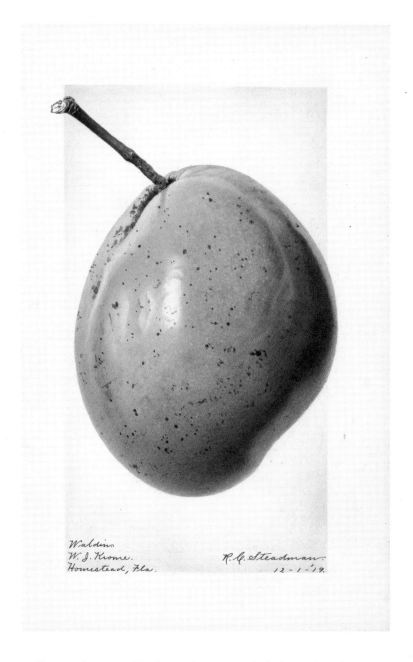

Waldin avocado exterior (Florida, 1919). Artist: Royal Charles Steadman.

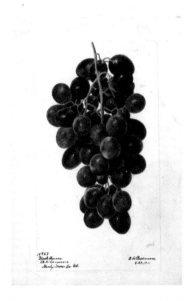

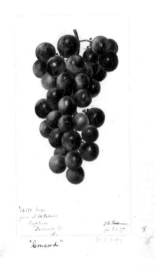

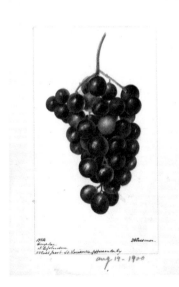

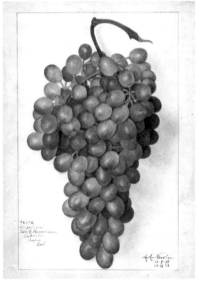

Clockwise from top left: Black Ferrara grape (North Carolina, 1900). Artist: Deborah Griscom Passmore. Concord grape (Alabama, 1897). Artist: Deborah Griscom Passmore. Angelina grape (California, 1908). Artist: Amanda Almira Newton. Templar grape (Kentucky, 1900). Artist: Deborah Griscom Passmore.

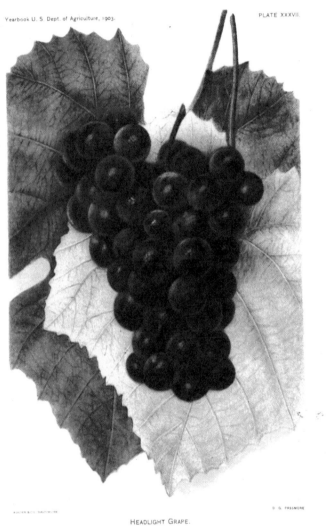

Yearbook U. S. Dept. of Agriculture, 1903.

PLATE XXXVII.

D. G. PASSMORE

HEADLIGHT GRAPE.

Headlight grape (Texas, 1903). Artist: Deborah Griscom Passmore.

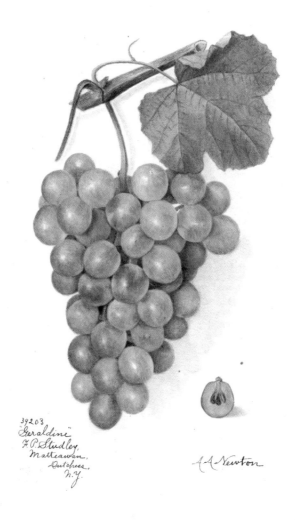

39203
"Geraldine"
F. P. Studley,
Matteawan.
Dutchess,
N.Y.

A. A. Newton

Geraldine grape (New York, ND). Artist: Amanda Almira Newton.

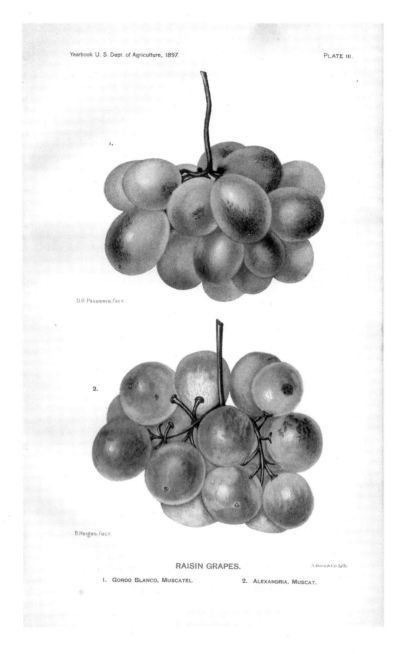

Yearbook U. S. Dept. of Agriculture, 1897.

PLATE III.

D.G Passmore. fecit.

2.

B.Heiges. fecit.

RAISIN GRAPES.

A.Hoen & Co. lith.

1. GORDO BLANCO, MUSCATEL. 2. ALEXANDRIA, MUSCAT.

Gordo Blanco, Muscatel and Alexandria, Muscat grapes (California, 1897). Artists: Deborah Griscom Passmore and Bertha Heiges.

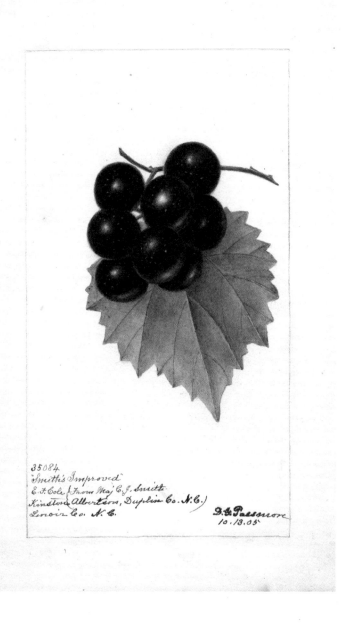

Smiths Improved grape (North Carolina, 1905). Artist: Deborah Griscom Passmore.

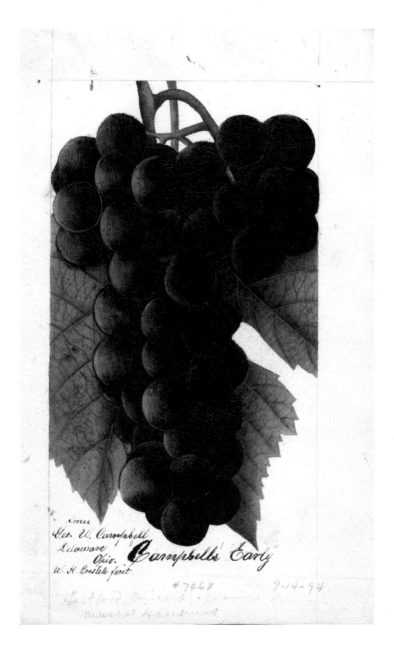

Cambells Early grape (Ohio, 1894). Artist: William Henry Prestele.

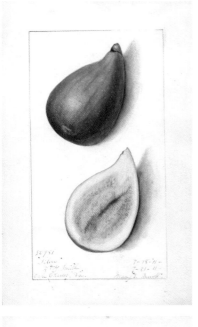

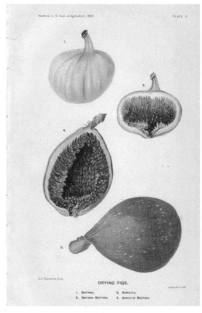

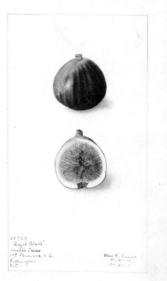

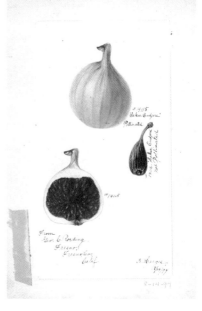

Clockwise from top left: Silver fig (Virginia, 1911). Artist: Mary Daisy Arnold. Smyrna and Adriatic figs (California, 1897). Artist: Deborah Griscom Passmore. Sekar Endjere fig (California, 1897). Artist: Bertha Heiges. Royal Black fig (Washington, D.C., 1910). Artist: Elsie E. Lower.

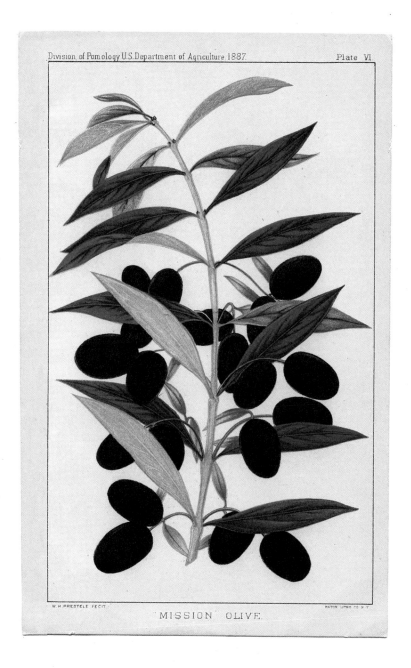

Division of Pomology U.S.Department of Agriculture 1887. Plate VI

W. H. PRESTELE FECIT

MISSION OLIVE.

Mission olive (California, 1887). Artist: William Henry Prestele.

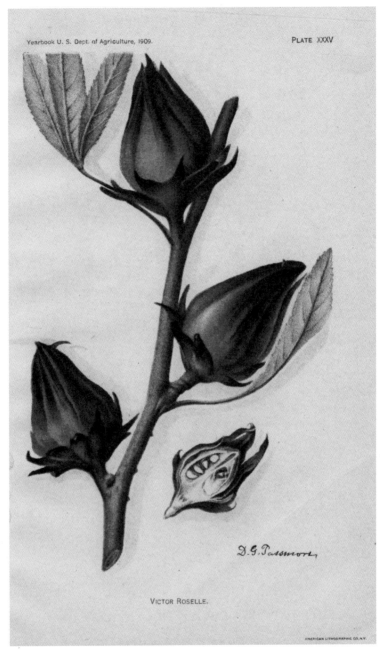

VICTOR ROSELLE.

Victor roselle (Florida, 1909). Artist: Deborah Griscom Passmore.

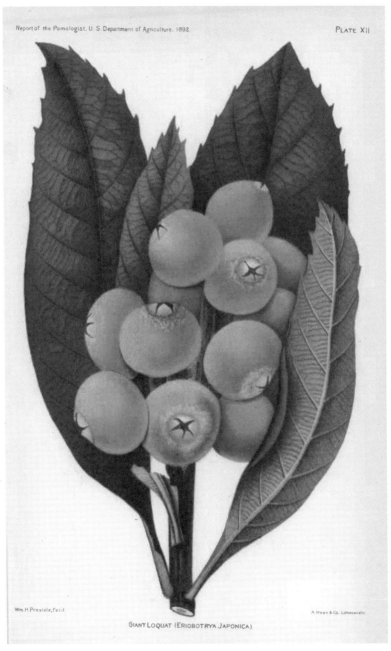

Report of the Pomologist. U.S. Department of Agriculture. 1892. PLATE XII

Wm. H. Prestele, fecit. A. Hoen & Co. Lithocaustic

GIANT LOQUAT (ERIOBOTRYA JAPONICA)

Giant loquat (California, 1892). Artist: William Henry Prestele.

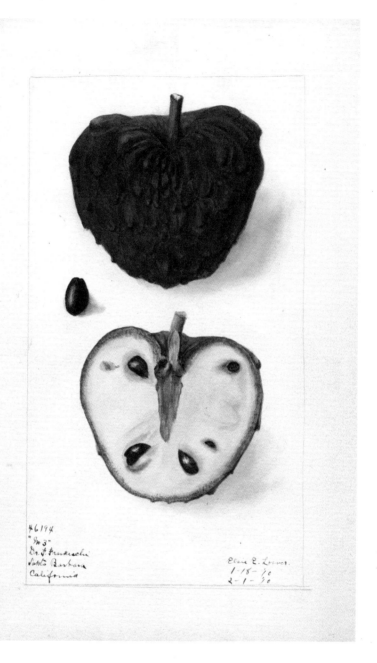

#46194
"No 3"
Dr. F. Franceschi
Santa Barbara
California

Elsie E. Lower.
1-18-'10
2-1-'10

No. 3 sweetsop (California, 1910). Artist: Elsie E. Lower.

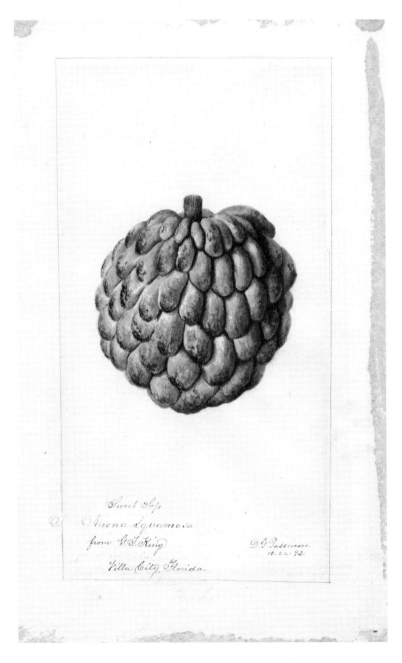

Sweetsop (Florida, 1892). Artist: Deborah Griscom Passmore.

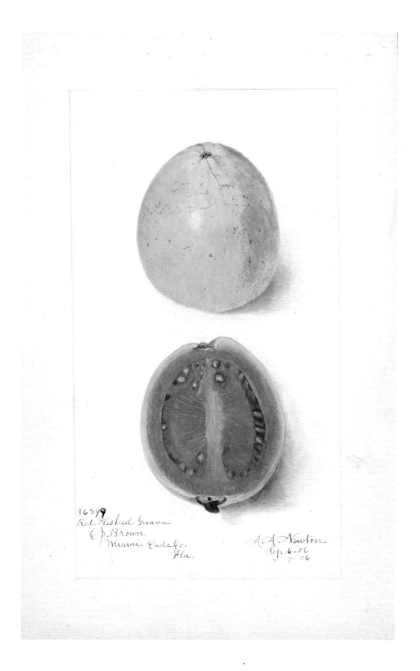

Red Fleshed guava (Florida, 1906). Artist: Amanda Almira Newton.

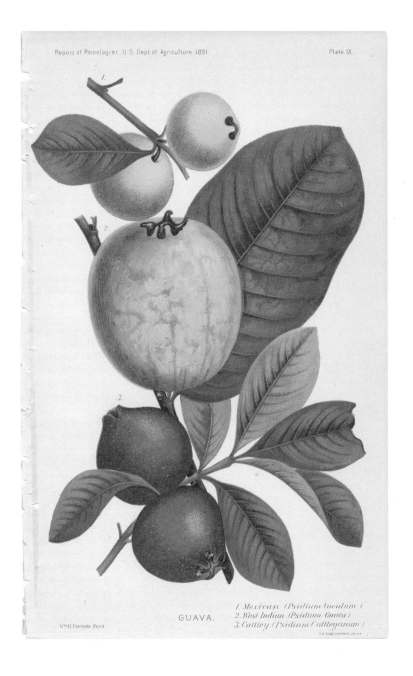

Report of Pomologist. U.S. Dept of Agriculture. 1891. Plate IX.

GUAVA.

1. *Mexican* (*Psidium lucidum*)
2. *West Indian* (*Psidium Guava*)
3. *Cattley* (*Psidium Cattleyanum*)

Wm. H. Prestele. Fecit

Mexican, West Indian, and Cattley guavas (1891). Artist: William Henry Prestele.

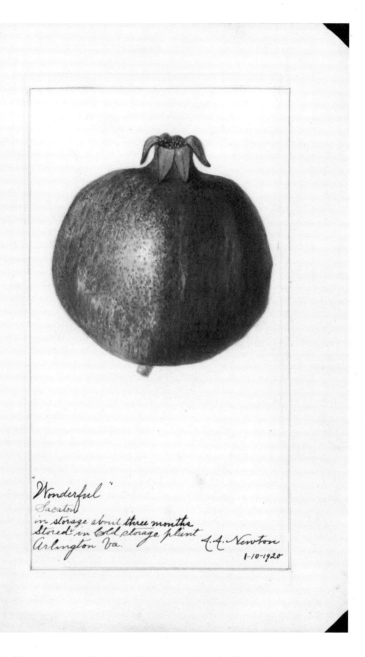

"Wonderful"
Sacaton
in storage about three months
Stored in Cold storage plant
Arlington Va. A.A. Newton
 1-10-1920

Wonderful pomegranate (Virginia, 1920). Artist: Amanda Almira Newton.

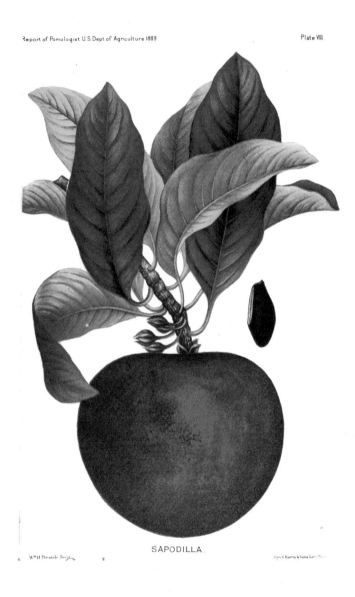

Report of Pomologist U S Dept of Agriculture 1889

Plate VIII

SAPODILLA.

Wm H Prestele Feet

Geo S Harris & Sons Lith Phil

Sapodilla (Florida, 1889). Artist: William Henry Prestele.

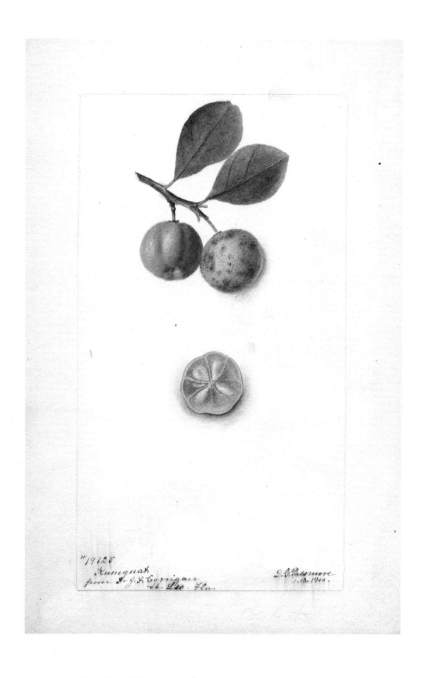

Kumquat (Florida, 1900). Artist: Deborah Griscom Passmore.

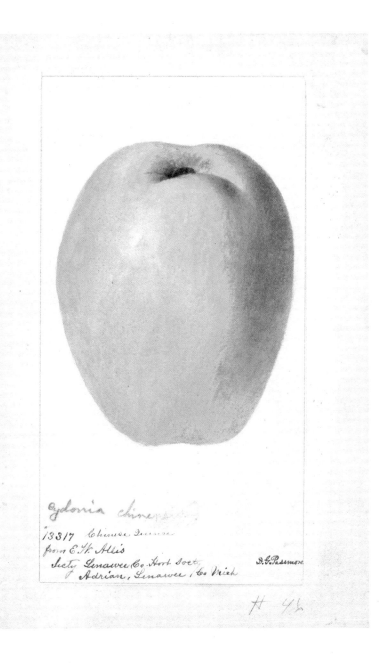

Chinese quince (Michigan, 1897). Artist: Deborah Griscom Passmore.

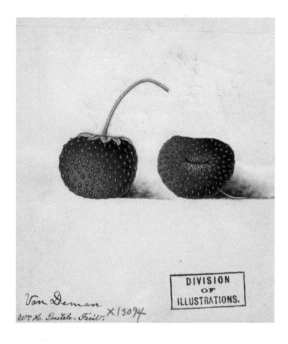

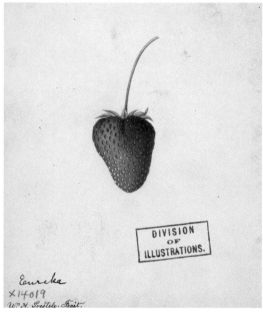

Top: Van Deman strawberry (Maryland, 1891). Artist: William Henry Prestele.
Bottom: Eureka strawberry (New York, 1911). Artist: William Henry Prestele.

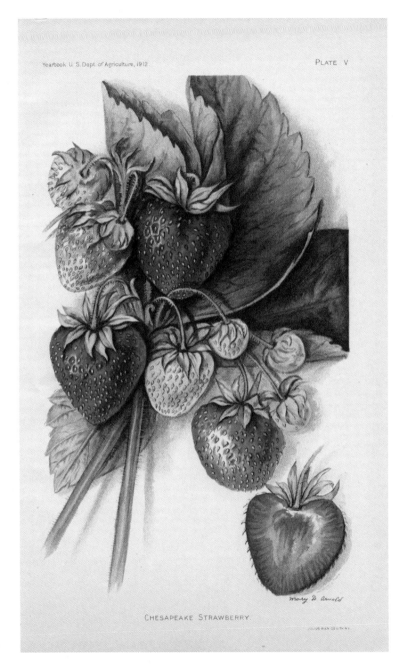

Chesapeake strawberry (Maryland, 1912). Artist: Mary Daisy Arnold.

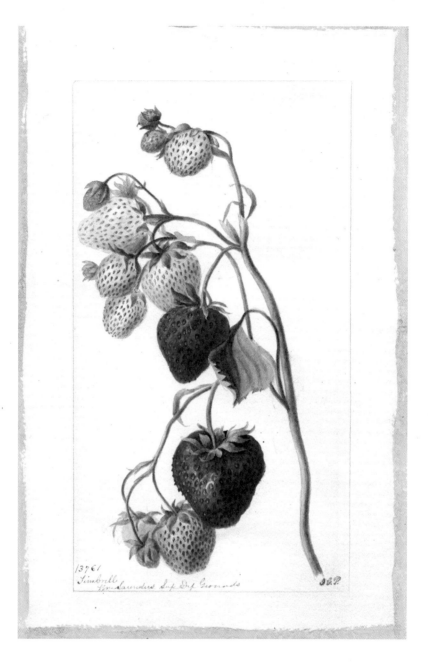

13761
Timbrell
Windsorandirs Sup Dup Grounds D.G.P.

Timbrell strawberry (Washington, D.C., 1897). Artist: Deborah Griscom Passmore.

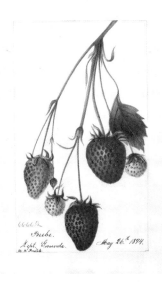

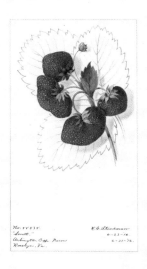

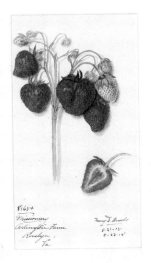

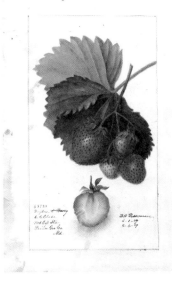

Clockwise from top left: Beebe strawberry (Washington, D.C., 1894). Artist: Deborah Griscom Passmore. Lovett strawberry (Virginia, 1916). Artist: Royal Charles Steadman. Dayton strawberry (Maryland, 1909). Artist: Deborah Griscom Passmore. Missionary strawberry (Virginia, 1915). Artist: Mary Daisy Arnold.

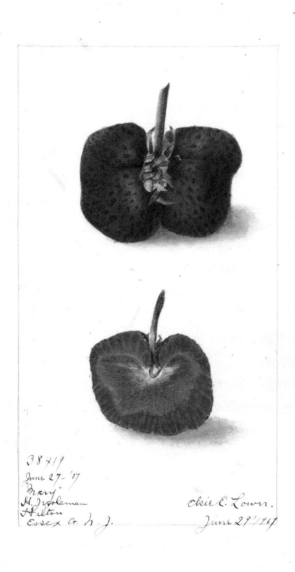

38419
June 27 - '07
"Mary"
H. Jerolaman
Hilton
Essex Co. N. J.

Elsie E. Lower.
June 29 1907

Mary strawberry (New Jersey, 1907). Artist: Elsie E. Lower.

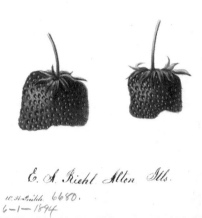

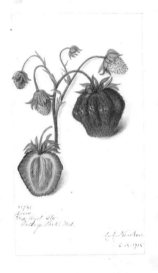

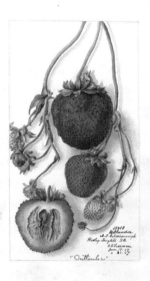

Clockwise from top: Strawberry (Illinois, 1894). Artist: William Henry Prestele. Outlander strawberry (Washington, D.C., 1907). Artist: Deborah Griscom Pass-more. Dew strawberry (Maryland, 1915). Artist: Amanda Almira Newton.

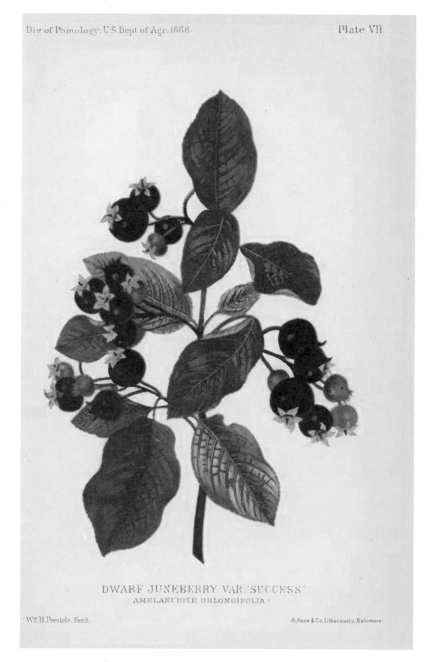

Div. of Pomology, U.S. Dept. of Agr. 1888.

Plate VII

DWARF JUNEBERRY. VAR. "SUCCESS"
(AMELANCHIER OBLONGIFOLIA)

W.ᵗ H Prestele, Fecit.

A. Hoen & Co. Lithocaustic Baltimore

Success dwarf juneberry (1888). Artist: William Henry Prestele.

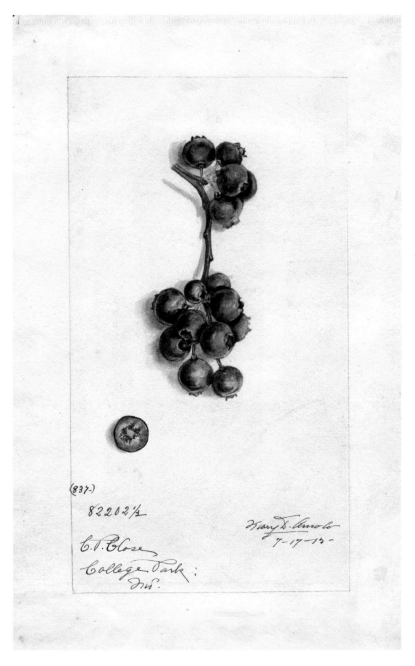

No. 837 blueberry (Maryland, 1915). Artist: Mary Daisy Arnold.

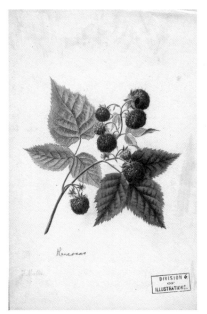
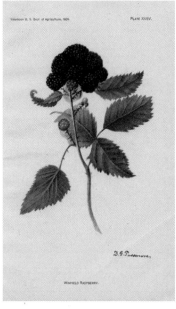
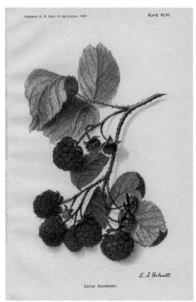
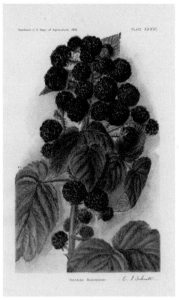

Clockwise from top left: Rancocas raspberry (Virginia, 1891). Artist: Frank Muller. Winfield raspberry (Kansas, 1909). Artist: Deborah Griscom Passmore. Hoosier raspberry (Indiana, 1910). Artist: Ellen Isham Schutt. Eaton raspberry (Michigan, 1908). Artist: Ellen Isham Schutt.

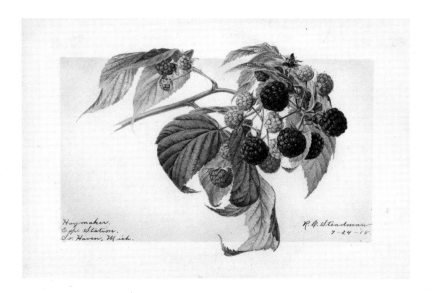

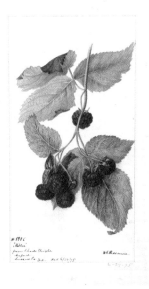
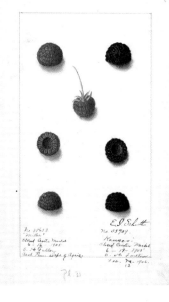

Clockwise from top: Haymaker purple raspberry (Michigan, 1918). Artist: Royal Charles Steadman. Miller and Kansas raspberries (1906 and 1905). Artist: Ellen Isham Schutt. Miller raspberry (Delaware, 1895). Artist: Deborah Griscom Passmore.

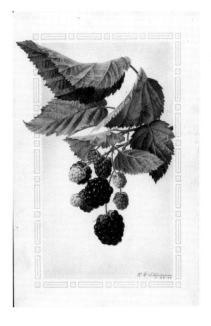

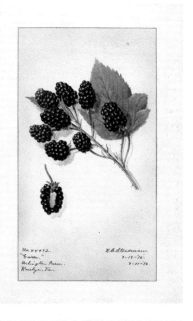

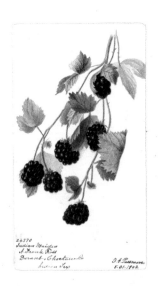

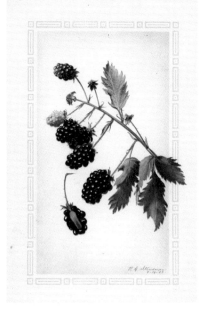

Clockwise from top left: Bramble berry (Maryland, 1924). Artist: Royal Charles Steadman. Garee blackberry (Virginia, 1916). Artist: Royal Charles Steadman. Mersereau blackberry (1922). Artist: Royal Charles Steadman. Indian Maiden blackberry (Choctaw Nation, 1902). Artist: Deborah Griscom Passmore.

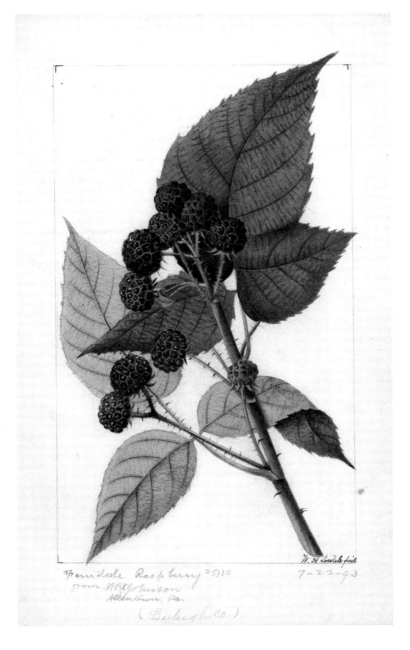

Ferndale black raspberry (Pennsylvania, 1893). Artist: William Henry Prestele.

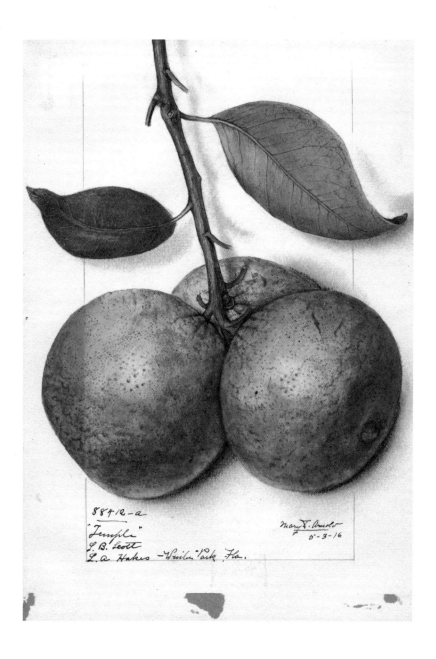

88412-a
"Temple"
S. B. Scott
L. A. Hakes — Winter Park, Fla.

Mary D. Arnold
5-3-16

Temple orange (Florida, 1916). Artist: Mary Daisy Arnold.

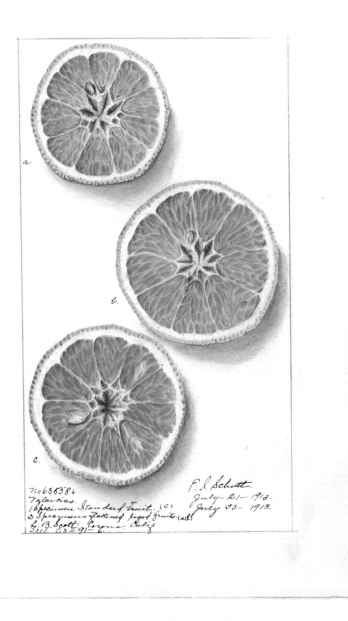

Valencia orange (California, 1913). Artist: Ellen Isham Schutt.

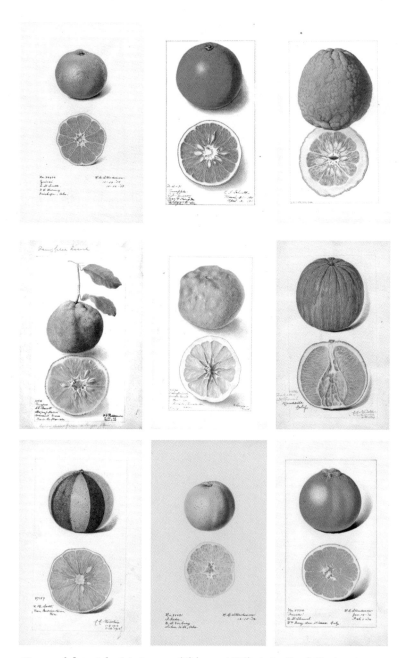

Top row, left to right: Jairai orange (Alabama, 1917). Artist: Royal Charles Steadman. Pineapple orange (Florida, 1911). Artist: Ellen Isham Schutt. Alamoen pomelo (California, ND). Artist: Louis Charles Christopher Krieger. Middle row, left to right: Rangpur orange (Florida, 1906). Artist: Deborah Griscom Passmore. Washington Navel orange (California, 1905). Artist: Bertha Heiges. Orange (California, 1916). Artist: Amanda Almira Newton. Continued next page.

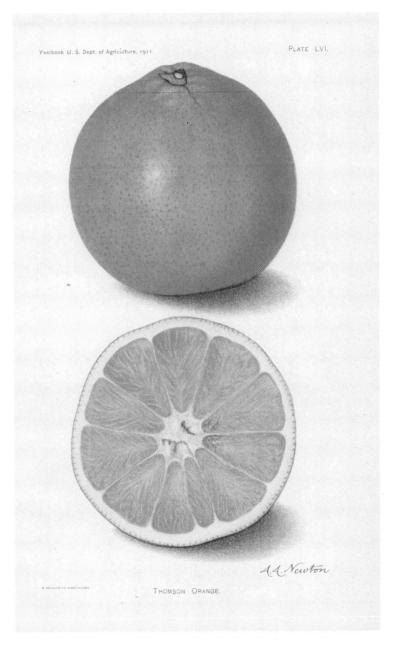

Yearbook U. S. Dept. of Agriculture, 1911.

PLATE LVI.

THOMSON ORANGE.

Above: Thomson orange (California, 1911). Artist: Amanda Almira Newton.

Continued from opposite page. Bottom row, left to right: Orange (Florida, 1915). Artist: Amanda Almira Newton. Ikeda orange (Alabama, 1919). Artist: Royal Charles Steadman. Fausta orange (California, 1916). Artist: Royal Charles Steadman.

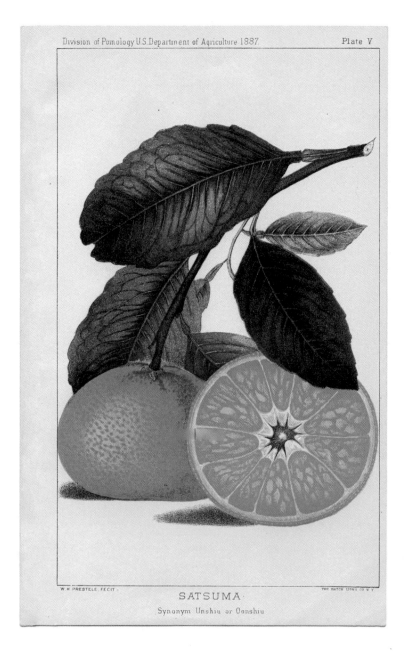

Division of Pomology U.S. Department of Agriculture 1887.　　　Plate V

W. H. PRESTELE, FECIT.　　　THE HATCH LITHO CO. N.Y

SATSUMA

Synonym Unshiu or Oonshiu

Satsuma (Florida, 1887). Artist: William Henry Prestele.

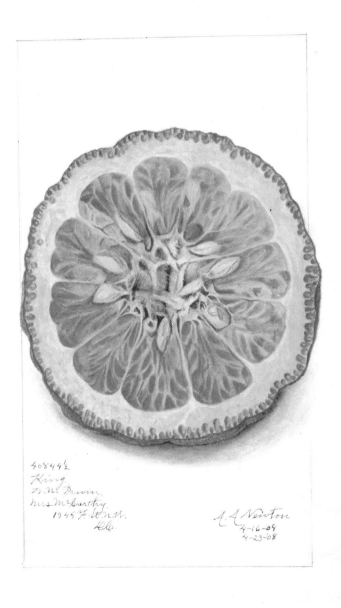

King tangor (Washington, D.C., 1908). Artist: Amanda Almira Newton.

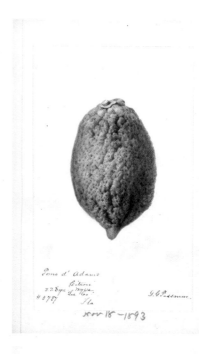

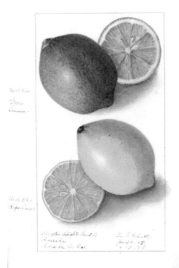

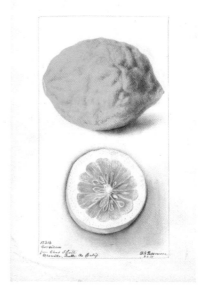

Clockwise from top left: Lisbon lemon (California, 1914). Artist: Amanda Almira Newton. Pomo d'Adams citron (Florida, 1893). Artist: Deborah Griscom Passmore. Corsican lemon (California, 1899). Artist: Deborah Griscom Passmore. Lemons, green and ripe (California, 1908). Artist: Ellen Isham Schutt.

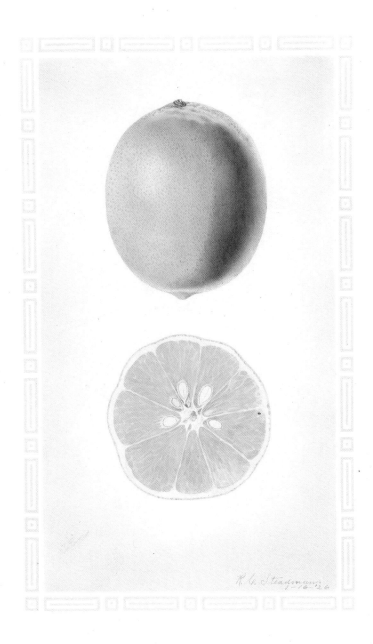

Meyer lemon (California, 1926). Artist: Royal Charles Steadman.

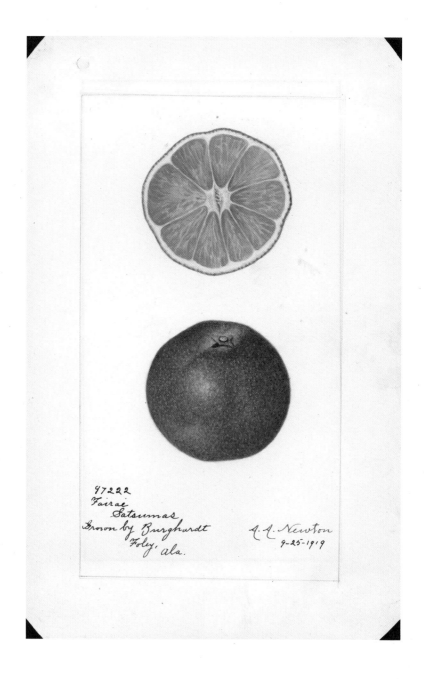

47222
Fairai
Satsumas
Grown by Burghardt
Foley, Ala.

A. A. Newton
9-25-1919

Fairai satsuma (Alabama, 1919). Artist: Amanda Almira Newton.

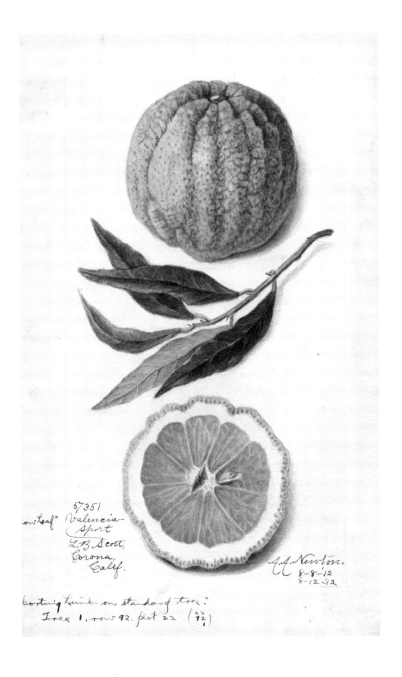

57351
ow Leaf" Valencia-
Sport
Z.B Scott,
Corona,
Calif.

A.A. Newton.
8-8-'12
8-12-'12

booting kink on standard tree."
Tree 1, row 92. plot 22 (22/92)

Valencia orange (California, 1912). Artist: Amanda Almira Newton.

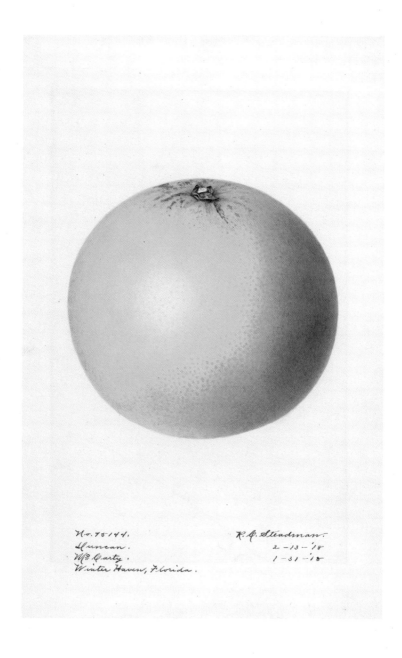

Duncan grapefruit (Florida, 1918). Artist: Royal Charles Steadman.

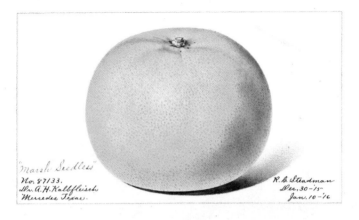

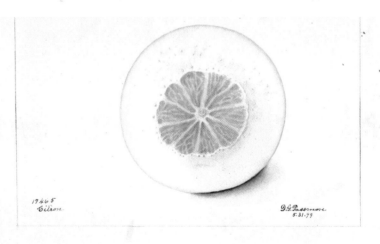

Top: Marsh Seedless grapefruit (Texas, 1916). Artist: Royal Charles Steadman.
Bottom: Citron (California, 1899). Artist: Deborah Griscom Passmore.

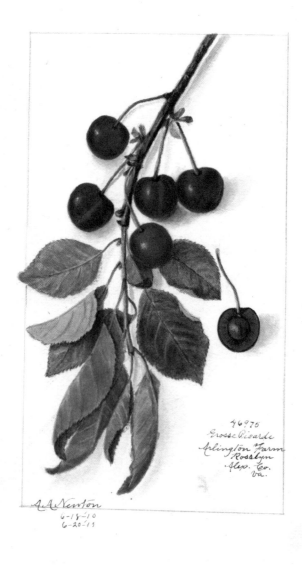

Grosse Picarde cherry (Virginia, 1910). Artist: Amanda Almira Newton.

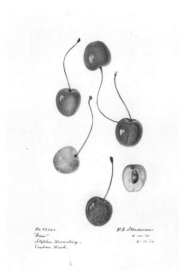

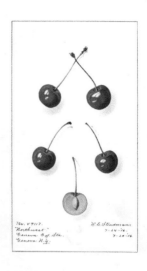

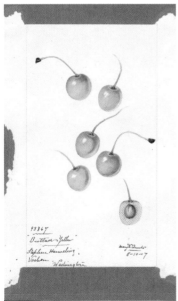

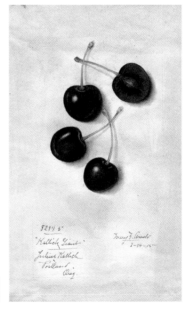

Clockwise from top left: Cass cherry (Washington, 1917). Artist: Royal Charles Steadman. Northwest cherry (New York, 1916). Artist: Royal Charles Steadman. Kallich Giant cherry (Oregon, 1915). Artist: Mary Daisy Arnold. Buttners Yellow cherry (Washington, 1917). Artist: Mary Daisy Arnold.

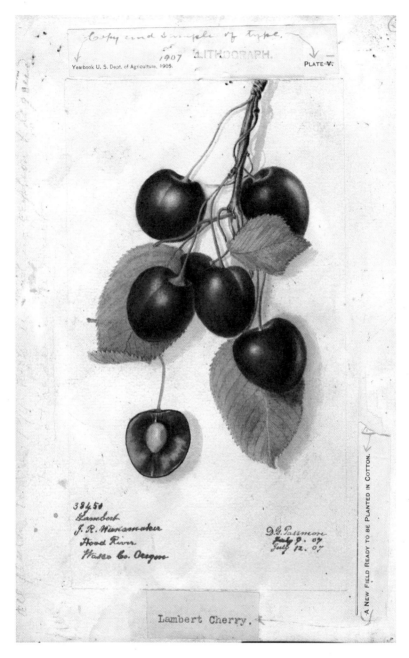

Lambert cherry (Oregon, 1907). Artist: Deborah Griscom Passmore.

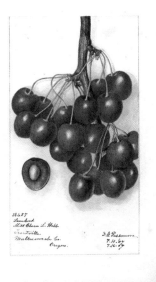
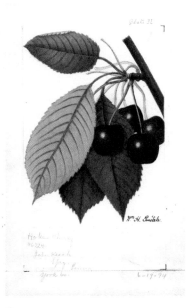
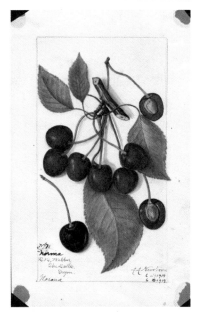
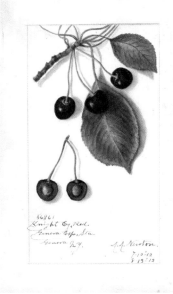

Clockwise from top left: Lambert cherry (Oregon, 1907). Artist: Deborah Griscom Passmore. Hoke cherry (Pennsylvania, 1894). Artist: William Henry Prestele. Knight Early Red cherry (New York, 1912). Artist: Amanda Almira Newton. Norma cherry (Oregon, 1914). Artist: Amanda Almira Newton.

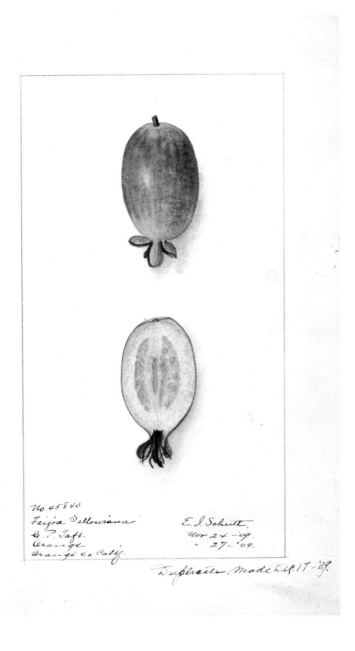

No. 45840
Feijoa Sellowiana
C. P. Taft.
Orange
Orange Co. Calif.

E. I. Schutt.
Nov 24 -'09.
" 27- '09.

Duplicate model Dec. 17 -'09.

Feijoa (California, 1909). Artist: Ellen Isham Schutt.

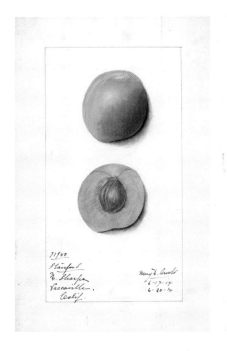

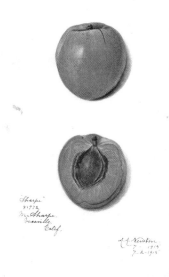

Left: Stanford apricot (California, 1914). Artist: Mary Daisy Arnold.
Right: Sharpe apricot (California, 1915). Artist: Amanda Almira Newton.

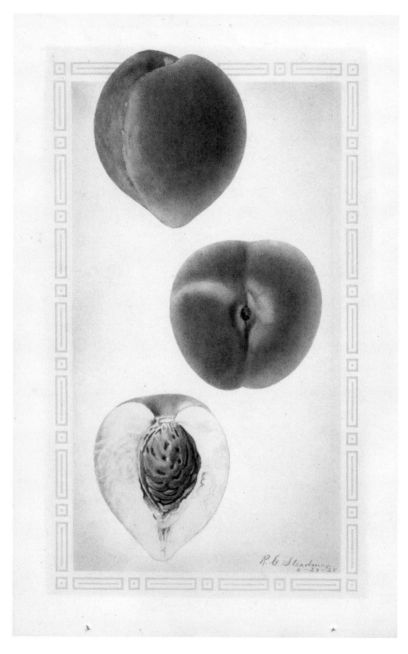

Above: Hiley peach (Georgia, 1925). Artist: Royal Charles Steadman.

Opposite page. Top row, left to right: Shumaker peach (Virginia, 1913). Artist: Mary Daisy Arnold. Wooster peach (Pennsylvania, 1907). Artist: Elsie E. Lower. Beals Late White peach (Virginia, 1908). Artist: Amanda Almira Newton.

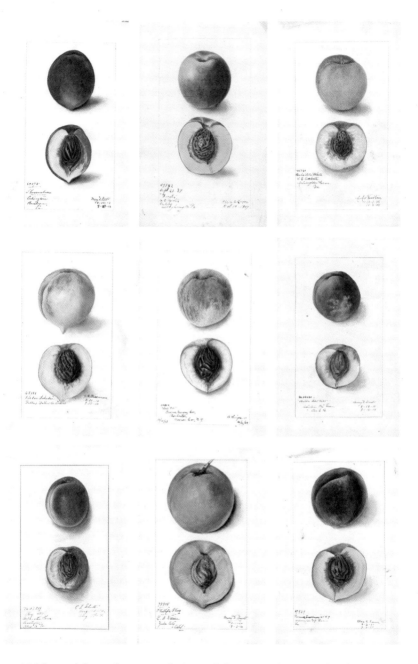

Middle row, left to right: Victor Labodie peach (Texas, 1910). Artist: Deborah Griscom Passmore. Capitol peach (New York, 1903). Artist: Bertha Heiges. Butler Late peach (Virginia, 1910). Artist: Mary Daisy Arnold. **Bottom row, left to right:** Ray peach (Virginia, 1911). Artist: Ellen Isham Schutt. Phillips Cling peach (California, 1914). Artist: Mary Daisy Arnold. Persia peach (Virginia, 1910). Artist: Elsie E. Lower.

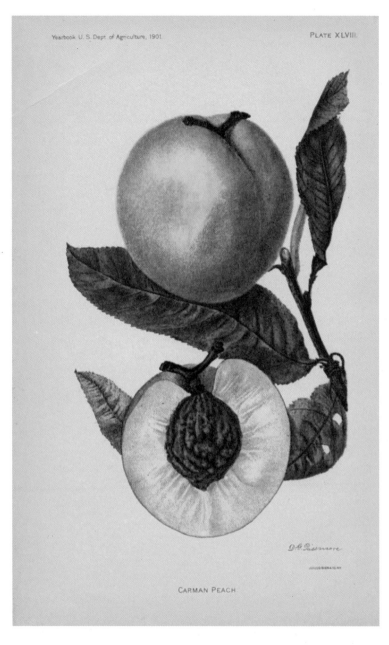

Carman peach (Texas, 1901). Artist: Deborah Griscom Passmore.

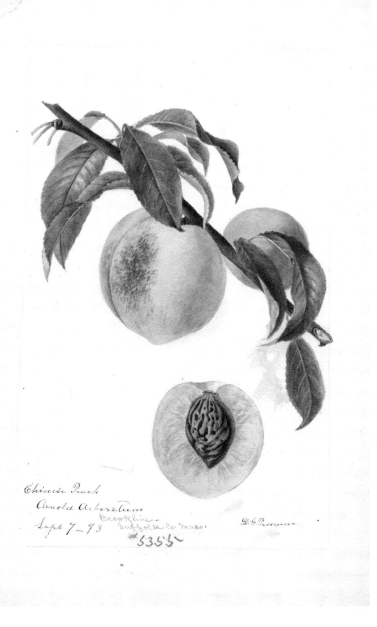

Chinese peach (Massachusetts, 1893). Artist: Deborah Griscom Passmore.

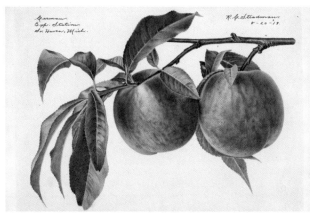

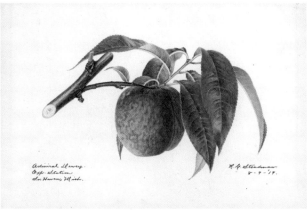

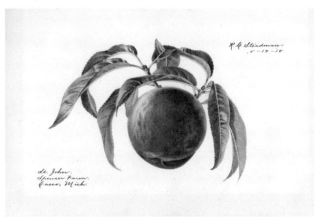

Top: Carman peach (Michigan, 1919). Artist: Royal Charles Steadman.
Middle: Admiral Dewey peach (Michigan, 1919). Artist: Royal Charles Steadman.
Bottom: St. John peach (Michigan, 1918). Artist: Royal Charles Steadman.

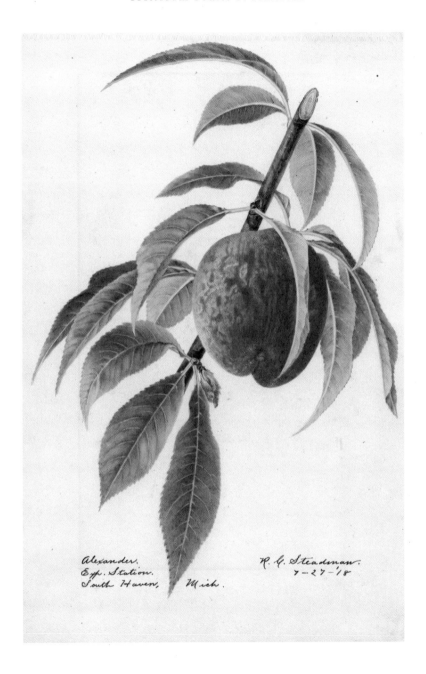

Alexander.
Exp. Station.
South Haven, Mich.

R. C. Steadman.
7-27-'18

Alexander peach (Michigan, 1918). Artist: Royal Charles Steadman.

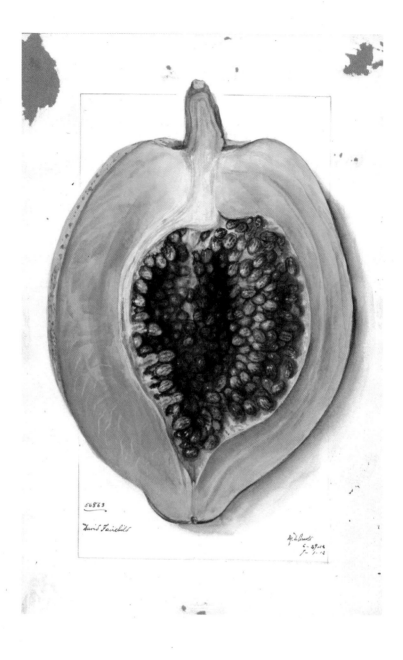

56863

David Fairchild

Papaya interior (1912). Artist: Mary Daisy Arnold.

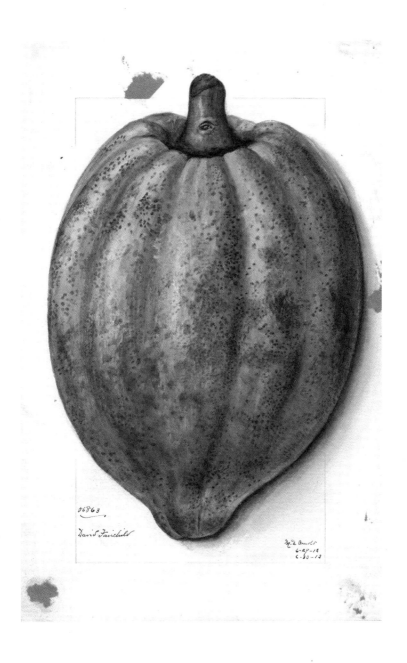

Papaya exterior (1912). Artist: Mary Daisy Arnold.

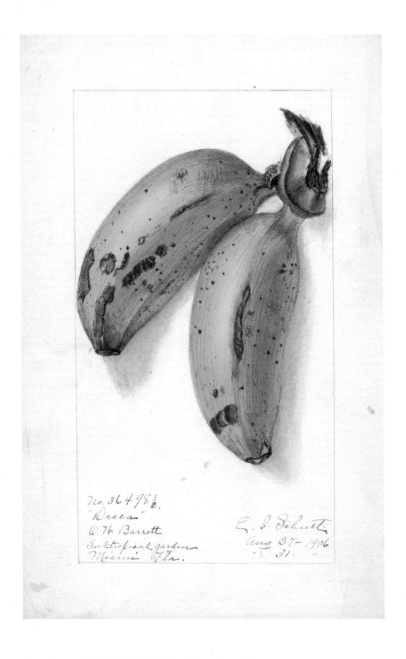

Dacca banana (Florida, 1906). Artist: Ellen Isham Schutt.